The
Story
of
Painting

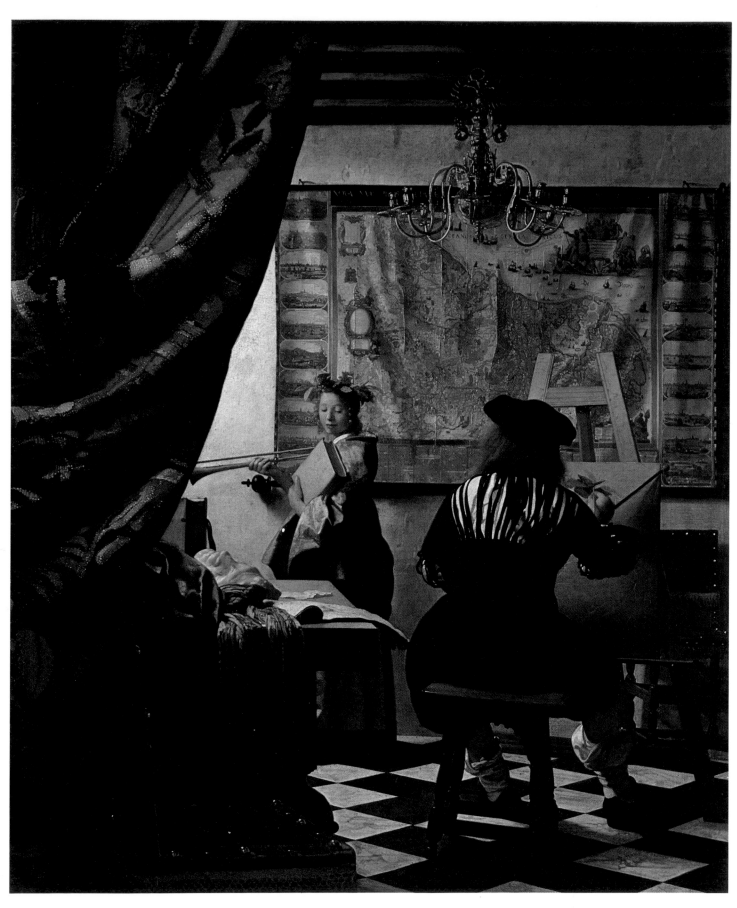

JAN VERMEER. *The Artist in His Studio*. About 1665–70. Kunsthistorisches Museum, Vienna

H.W. JANSON AND DORA JANE JANSON

The Story of Painting

FROM CAVE PAINTING TO MODERN TIMES

HARRY N. ABRAMS, INC., Publishers, NEW YORK

Revised and updated by Anthony F. Janson

Edited by Patricia Egan

Designed by Julie Bergen

Library of Congress Cataloging in Publication Data

Janson, Horst Woldemar, 1913–

The story of painting, from cave painting to modern times.

First ed. published in 1952 under title:
The story of painting for young people. Includes index.
1. Painting. I. Janson, Dora Jane, 1916– joint author. II. Title.

ND50. J335 1977 759 77–2238
ISBN 0–8109–2068–9

Library of Congress Catalog Card Number: 77–2238
Published in 1977 by Harry N. Abrams, Incorporated, New York

Contents

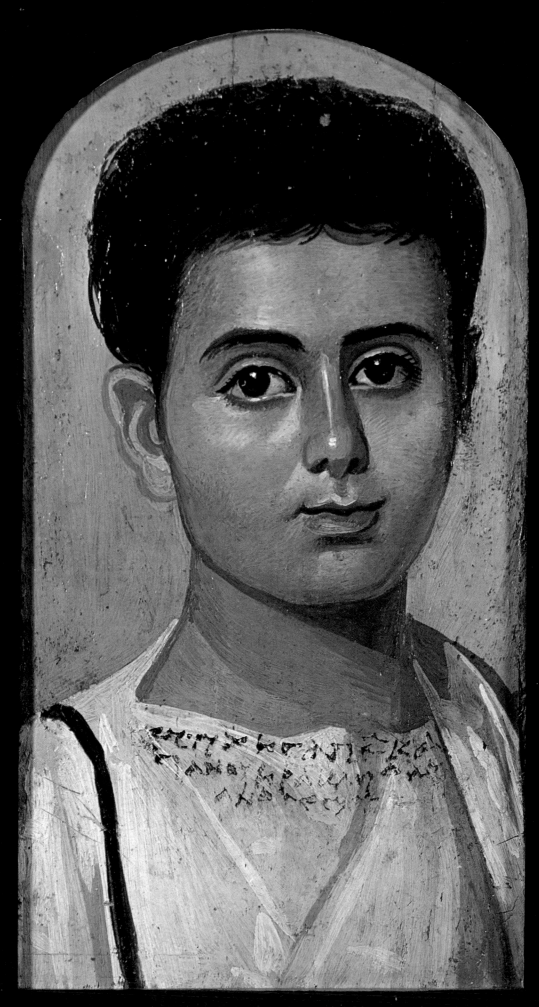

1. *Portrait of a Boy*. From Fayum, Egypt. Third century A.D.
Metropolitan Museum of Art, New York

1

How Painting Began

People all dream, whether they want to or not. Even animals dream. A cat's ears and tail sometimes twitch in his sleep, while dogs whine and growl and paw the air, just as if they were having a fight. Even when they are awake animals "see things," so that a cat's fur will rise on his back, for no apparent reason, as he peers into a dark cupboard. And we, too, have goose pimples when we feel frightened.

That is imagination at work. People are not the only animals who have imagination, but we are the only ones who can tell each other about it. If we tell each other in words, we have made a story out of it, and if we take a pencil and draw it, we have made a picture. To imagine means to "make an image" or a picture, in our minds.

There are many different ways for our imaginations to get started. Thus it may happen, at times when we are ill in bed with nothing to do, that a crack in the ceiling will suddenly begin to look like an animal or a tree after we have kept our eye on it for some time. Our imagination fills in the lines that aren't there. Even an ink blot on folded paper (plate 2) will make us think of a lot of other things, although it was made entirely by accident. Psychologists know this and have made up ink-blot tests to find out what is on our minds; for each of us, depending on the sort of person we are, will see different pictures in the same blot.

Artists also make use of ink blots to stimulate their imaginations. If you look carefully at *Landscape with Figures* (plate 3) by Salvador Dali, you will see that the main shapes (the rocks, the beach, and the clouds) are actually ink blots made by chance. All Dali had to do was see a picture "into" the blots and then fill in the missing lines, so that others can see it, too. This does not mean that the drawing is less of a work of art just because Dali has accepted the "help" of the ink blots.

The making of a work of art has little in common with what we ordinarily mean by "making." We all tend to think of "making" in terms of the craftsman or manufacturer who knows from the outset exactly what he wants to produce. The creative process, on the other hand, consists of a series of leaps of the imagination and the artist's attempts to give them form by shaping his materials. It is a strange and risky business in which the maker never quite knows what he is making until he has actually made it. To put it another way, it is a game of hide-and-seek in which the seeker is not sure what he is looking for until he has found it.

The way the imagination works is similar in all people. It is still much the same as it was in the days when cavemen first began to paint. Only the things we imagine and the way we put them into pictures have changed. These changes are what the story of painting is about.

THE MAGIC PICTURES OF THE CAVEMEN

In the Old Stone Age, some 35,000 years ago, when the first known pictures were

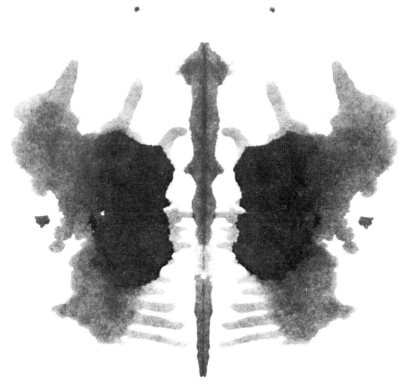

2. Ink blot on folded paper

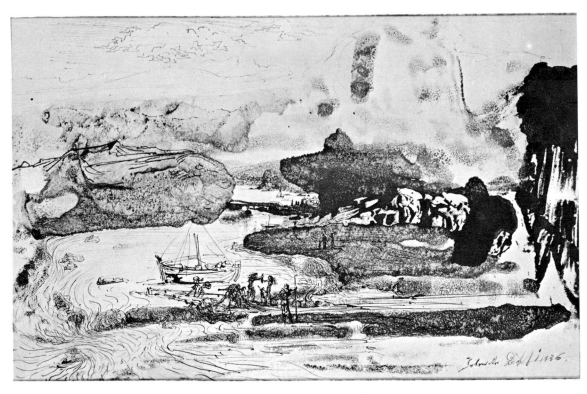

3. SALVADOR DALI. *Landscape with Figures* (*Return of Ulysses*).
Ink blots, brush, and pen drawing. 1936. Private Collection, New York

How Painting Began

made, people lived in caves, and their main concern was how to find enough to eat. They had not yet learned how to keep cattle, and they did not know about farming, so they depended mainly on hunting for their food supply. When the hunting had not been good, they had to go hungry. There were, of course, all sorts of birds and fish and small animals they could catch, but these were not enough to live on, so they always hoped to kill something big, like a deer or a buffalo, that would yield enough meat to last them several weeks. They wanted very badly to kill these animals, but they were afraid of them, too, for they only had the simplest of weapons as yet. In fact, since they knew nothing about metal, whatever tools they possessed were made of wood, bone, or stone. And they had to hunt on foot because they had not yet learned how to ride horses.

No wonder, then, that the cavemen's minds were always full of the idea of hunting large animals for food, and of how dangerous this was. And because they thought so much about these things, it is not surprising to find that almost all of their paintings are of these animals, which always look very powerful and lifelike (plate 4).

How did the cavemen learn to make such skillful pictures? We don't really know for sure. But since the pictures are done on the sides of caves, which are rough and bumpy, it is possible that the idea of making pictures came from these bumps, just as the ink blot suggests ideas to us. Some hungry caveman, staring at the wall of his cave, may have imagined that a particular bump looked like an animal and perhaps drew an outline around it with a burned stick from the fire. He could then complete the picture by filling in the parts that were not there, and finally he learned how to make such a drawing without the help of the bump on the wall of the cave. It must, however, have taken thousands of years of slow growth, about which we know nothing, to achieve the assurance and refinement seen in the painted bull in plate 4.

Our next picture (plate 5) is a photograph that shows you a long stretch of a cave wall, and you will notice that the animals are all scrambled together, without any kind of order. Once you get them sorted out, you can recognize each one easily. Why, then, did the cavemen spoil their pictures by doing one on top of another? It is because they did *not* want them for decorations. Even if the pictures were not such a jumble, we could tell this from the fact that all the caves that have pictures in them are very dark and difficult to get into.

If the cavemen artists had done their animal paintings merely for pleasure, they would have put them near the entrance of the cave, where everybody could look at them. But they are so far back in the caves and so well hidden that they have been discovered only recently, and then by chance. The cave in plate 5 was, in fact, found in 1940 by some boys who had gone out hiking with their dog. Suddenly the dog was gone. They could hear him barking somewhere under the earth, but they could not see him until they found the hole, overgrown with brambles and weeds, through which he had fallen into the cave.

But what were the pictures for, then? They must have been a kind of hunting magic, because some of the animals have spears or arrows sticking into them. The cave-

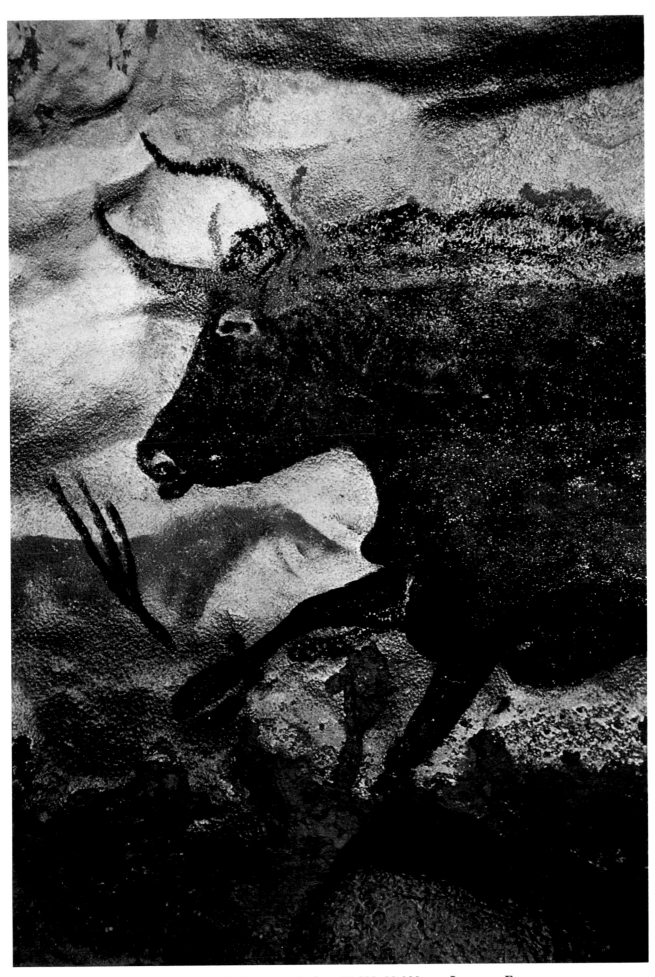

4. *Black Bull*. Detail of a cave painting. 15,000–10,000 B.C. Lascaux, France

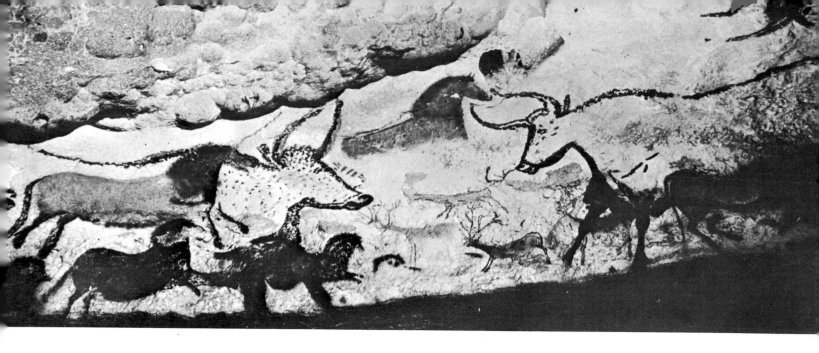

5. *Wild Animals.* Cave painting. 15,000–10,000 B.C. Lascaux, France

men thought that in "killing" the paintings they had killed the animals' vital spirit and hence the animals themselves. Perhaps they threw stones or jabbed the picture with their spears, too. This made them feel stronger and surer, so that when they finally went out to hunt that buffalo, they had a better chance to get him because they were no longer afraid. Once they had "killed" the picture, they did not care about it any more. One cannot kill a real animal twice, and so they felt that one cannot kill a painted animal twice, either. The next time they got ready to hunt, they had to make a new picture to "kill" first.

It is remarkable that the cavemen took so much trouble with their animal paintings. After all, they were going to use them only once. Perhaps they felt that the magic worked best if the animal looked as much like the real thing as possible. The main purpose may no longer have been to "kill" but to "make" animals—to increase their supply, perhaps through seasonal rituals—at a time when the great herds of game became scarce as the climate of Central Europe grew warmer.

In any case, it took a good deal of skill to make such convincing pictures. There must have been some cavemen who were better at this than the rest—who had special talent for art. After a while these men were probably allowed to stay home and practice making pictures, while all the others had to go out hunting. Even 35,000 years ago, then, the painter was a special kind of person, although we might say that he was mainly supposed to be a magician.

Today we no longer believe in that kind of magic. We know better than to confuse living things with the pictures of these things. But even now our feelings sometimes get confused, no matter what our reason tells us. For instance, it still happens that after a sudden quarrel people will tear up the photograph of someone they used to love; they know quite well that they cannot actually hurt anybody by doing so, yet it gives them great emotional satisfaction. Therefore, it need hardly surprise us that the men of the Old Stone Age, who understood far less than we do about the difference between thinking and feeling, could confuse pictures with real things.

Art is always as much concerned with the way people feel about things as it is with the way things really are. Usually, both knowing and feeling go to make up a picture,

12

and so paintings are different from one another, depending on whether the artist was more interested in what he saw or knew, or in what he felt; also on *how much* he saw, and knew, and felt.

PICTURES FOR THE DEAD: EGYPT

The cave pictures tell us a good deal about life in the Stone Age, and also about the way our imagination works. We say "our" imagination, because the minds of the cavemen were not really so very different from our own, otherwise we would not understand their pictures as well as we do. The difference between us and the cavemen is not in the kind of minds we have. It is in the things we think about and feel about. Perhaps pictures will also help us to understand how men managed to leave the life of the Stone Age behind and how, over many thousands of years, they gradually changed into the kind of people we are today.

When we speak of these changes we call them *history*. There are many ways of looking at history. Perhaps the simplest is to ask ourselves about the main differences between us and the men of the Stone Age. Even though the cavemen had far greater physical strength than we do, their life was very much more dangerous than ours—and also much less interesting. The big animals they hunted were really their masters, because the people depended on them so completely. When the animals moved away, they had to move with them, so they built rough shelters for themselves, never houses. And if they could find no animals to hunt, they starved. In the Stone Age, men worked together only in hunting (and the painters helped, too, with their magic), but today we cooperate in a thousand complicated ways, so that we depend on each other much more than the cavemen did.

Now, this modern way of living could come about only because we are very much more orderly than the people of the Stone Age. We think ahead. We *plan* things, while the lives of the cavemen were just as disorderly as their paintings. How did they discover that they needed order? Just as soon as they found out that there were ways of controlling their supply of food instead of letting the food supply control them. First they learned how to tame and keep some of the animals they had hunted before. They became herdsmen who moved about with their sheep, or goats, or cattle, or camels, always looking for grazing lands.

Other people found a different and even better way to control their food supply. They tamed not only animals but plants, too, collecting the seeds and growing their own crops. In order to do this, they needed a warm climate and a good source of water. That is why the first farmers settled along the banks of the big rivers, such as the river Nile, in Egypt. And we shall now take a better look at these old Egyptians, because the history of Europe and America really begins with them. When they started planting their grain, they also planted the seeds of a way of life which has grown into our own way of life today.

The picture in plate 6 shows you a part of the oldest painting in Egypt. It was made

How Painting Began

on the wall of a temple or tomb in a place called Hierakonpolis, on the banks of the river Nile, more than 5000 years ago. There are some lively animals in it, and people fighting with them and with each other. The big white shapes are boats. At this time, then, the Egyptians still did a lot of hunting, but they no longer depended on it as the cavemen had. They knew how to make and use all sorts of tools, for they built solid buildings of brick and stone, with smooth walls, and boats for sailing up and down the river. Along the valley there must have been many separate tribes or states that made war on each other. Notice the two men in the lower right-hand corner: the one with the white, dotted body is beating the one with the black body, who belongs to another tribe.

If you compare this picture with the cave paintings, you will find that the figures in it are not nearly so real-looking. There is no shading such as we see in the bull (plate 4). They seem flat, as if they were glued to the wall, and the artist has left out many details. He uses a kind of shorthand, the way modern comic strips sometimes do, so that a circle with a dot in it stands for a face, a crooked line stands for an arm, and so on.

As a matter of fact, the Hierakonpolis painting was probably meant to tell a story, somewhat like a comic strip. At the time it was made, the Egyptians had just invented the earliest kind of writing, which was done with pictures and is called hieroglyphics. The painter now was also a writer. When he had to tell a story he did it with these simple figures, which were actually "letters" or "signs" that stood for things or words. Because the figures were used over and over again, they became less and less real-looking as time went on. We say they became "conventional" or "stylized"—and at last they turned into the letters of our own alphabet, which are no longer pictures at all.

There is something else we notice about the Hierakonpolis painting. We cannot tell whether or not the figures in it are supposed to be connected in some way, because there is no "setting," no indication of landscape or even of the ground they stand on. But there is no messy overlapping either, and the artist has been careful to spread the figures evenly over the whole surface of the wall. These animals, then, were not made to be "killed" for hunting magic. They were meant to be permanent. But Egyptian painting is connected with another, more complicated kind of magic; and in order to understand that we must know something of Egyptian ideas about religion, and especially about life and death.

When the Egyptians settled down to farming, order and planning became much more important to them than ever before. They had to know when to plant and harvest their crops. So they began to observe the regular movements of the sun, the moon, and the stars, and made up a calendar almost as good as our own. They also kept written records. But the Egyptians found that their harvest depended on a great many things besides the time of year. If the weather was bad, or if they did things the wrong way, they would not have enough food for the winter.

It was hard for them to understand why this sometimes happened, while at other

6. *Men, Boats, Animals.* Wall painting. About 3000 B.C. Hierakonpolis, Egypt

times everything turned out just right. The only explanation they could think of was that the sun, the moon, the clouds, the water, the animals, the plants, and even the earth itself, were all inhabited by powerful spirits that could be either helpful or harmful, depending on whether they liked you or not. The more important among these "nature spirits" came to be worshiped as gods. The Egyptians thought of them as great rulers similar to their own kings (who were also divine), except that they were wiser and lived forever.

"Forever" was a very important idea with the Egyptians. They believed that their kings, the Pharaohs, and other important and wealthy people had a vital spirit, or soul, inside them, and that when a person died his soul would leave his body and keep on living separately. But they also thought that in this "afterlife" the soul still needed a body to come back to. Because of this, they went to great trouble to preserve the bodies of the dead—they made mummies of them by drying them and wrapping them up, and then put them in strong tombs made of stone, so nobody would disturb them. And they put statues in tombs as "replacements," in case something should happen to the real body.

They also believed that the spirit of the dead needed the same material things as a living person, so they furnished their tombs like a regular household, except that everything was made to last forever. Now, of course, even the richest man could not take all the things he owned with him into the tomb, such as his land, his animals, and his servants. Instead, he had pictures of them made on the walls, where his spirit would find them.

Plate 7 shows you such a wall painting, or "mural," from a tomb in Thebes, done about 1800 years after the one from Hierakonpolis. It was painted almost exactly 1400 years B.C., before the birth of Christ, during a period of Egyptian history known as the Empire, when the power of the Pharaohs reached far beyond the Nile valley proper into the neighboring regions to the east and south. At the top of the mural,

15

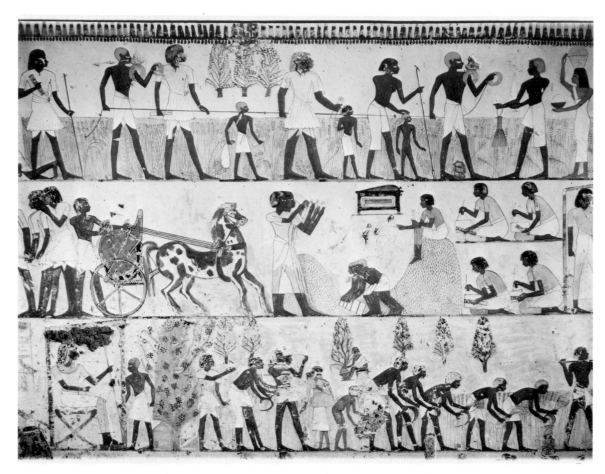

7. *Harvest Scenes*. Wall painting in a tomb. About 1400 B.C. Thebes, Egypt

the dead man's servants are measuring a wheatfield with a rope. At the bottom, they are cutting the wheat with sickles, while the dead man himself sits under a canopy which protects him from the sun. In the center level there are his chariot and some servants measuring a pile of grain. This harvest scene strikes us as very orderly and carefully drawn. The figures no longer look as if they were floating—they have their feet firmly on the ground, even if the ground is only a thin, straight line. We can also tell right away what they are doing.

Still, the picture is not very lifelike. For one thing, many of the figures are put together in a strange way: their heads, arms, and legs are seen from the side, while the bodies and the eyes are seen from in front. Now, the artist must have known that we don't see people that way in real life. In real life, we never get a very good view of anything in one glance, because most things are round rather than flat, and we can see only one side of them at a time. We don't really mind this, for if we want to know what is around the corner, we just walk up to it and then take another look; or if we see somebody's back and want to know what his face is like, we wait until he turns around. But we can't walk through a picture, and the figures in it cannot turn around. So the Egyptian painter made up for this by inventing a special kind of human figure where all the important parts of the body show up equally well in one view. Apparently this formula was originally worked out to convey a sense of the Pharaoh's majesty. The Egyptian artist, however, did not hesitate to abandon it

16

when he was showing everyday activities of other people. He knew that in real life a harvest is a complicated business, with many people doing different things one after the other. We would have to watch them for quite some time if we wanted to understand what they are doing. How could the same story be told in a picture, where there is no space and no movement?

The Egyptian artist realized that a lifelike painting, of the kind the caveman had done, was not what he wanted, because it would let him show the harvest only the way it looked at one particular moment, and not the whole story of the harvest. These scenes are part of a cycle of seasons, a sort of perpetual calendar of recurring events that the spirit could watch year in and year out. So our painter has made everything much clearer and more orderly than it ever is in real life. His figures are spread out on the wall, and they overlap only when several of them are doing the same thing; some are extra large, to show that they are more important than the others. And if he wants to tell us that something is far away, such as the three trees in the top strip, he puts it above, not behind, the figures in the foreground.

Our painter, then, does not show us what he actually *sees*, but what he *knows*. He follows a strict set of rules, which we call the Egyptian "style"—the Egyptian painter's way of doing things. These rules may strike us as a bit peculiar at first, but after a while we come to feel that they are really very wise and well thought out. Sometimes, too, the rules could be broken. Look at the horse in our picture: its dappled color, its prancing movement, make it seem much gayer and livelier than the rest. Now, horses were unknown in Egypt when the rules for painting were set up. They came to the Nile valley only 200 years before the date of our picture, which was not a very long time for the Egyptians, so our painter did not know how to apply his rules as strictly as usual in this case. And that is why the horse looks so much less "frozen" than the other figures.

PICTURES FOR THE LIVING: CRETE

If you took a ship from the mouth of the Nile and sailed north and a little to the west on the Mediterranean Sea, you would come to a long, rocky island called Crete, and then to the southern tip of Greece. There, between 2200 and 1100 B.C., you would have found a marvelous nation of sailors quite unlike the Egyptians. While the riches of Egypt came mainly out of the Nile valley, the Cretans were bold traders and pirates who made up for the poor soil of their homeland by bringing in food and many other important things from all the countries round about.

We have recently learned how to read their writing, so that we are beginning to know something about them. But from the ruins of their palaces, some of which have been dug up and partly rebuilt, and from the pictures they did, we can guess that they were just about the richest and happiest of the early Western nations. One of the palaces even had toilets that flushed, something almost unheard of until about a hundred years ago.

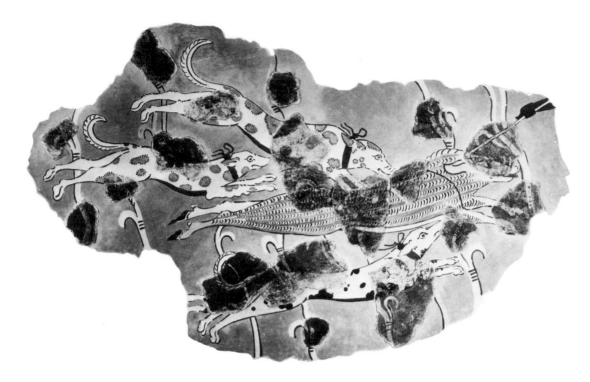

8. *Wild Boar Hunt.* Wall painting from the Palace of Tiryns, Greece.
About 1200 B.C. National Museum, Athens

The wild boar hunt in plate 8 is a Cretan painting from the walls of the Palace of Tiryns, in southern Greece, done about 1200 B.C. Unfortunately, only a small portion of it has come down to us, so we can no longer see the hunter whose hand, on the right, sticks a spear into the animal. But what is still there—the racing hounds and the ferocious, galloping boar—reminds us more of the cave paintings, with the vigorous, real-looking animals, than it does of the "frozen" Egyptian style. Still, the Cretan painter must have learned something from the Egyptians, for his picture, despite its rapid movement, is an orderly scene, not just a wild tangle of animals. And like the Egyptians, he makes his forms cling to the wall, and he follows definite rules—the three dogs are all done from the same pattern, except for their spots. There is no hunting magic here, but there is no service of the dead, either. For the Cretans, boar hunting was a sport, and the picture was done not from fear but for pleasure. It tells us of the thrill of the chase, and of the enjoyment of nature that we find in all of Cretan art. The gay and graceful shapes, the clear colors, must have made it a splendid decoration for the palace wall.

GREEK AND ROMAN PAINTING

The Cretans were conquered, and their palaces destroyed, by warlike tribes that came into Greece from the north around 1100 B.C. These Greek tribes also learned a great deal from the Cretans, and this helped them to build up a great civilization of their own—greater, in some ways, than the world has seen since. They soon settled and formed separate states, each named after its main city. Athens, in the region we call Attica, became the most important of these city-states, and it was there, between the eighth and the third centuries B.C., that the Greeks produced their keenest thinkers and their finest artists.

18

How Painting Began

When we talk about the masterpieces of Greek art, we usually think of temples and statues, and not of paintings. That is because quite a few of the famous temples and statues are still there, but the paintings that used to be on the walls of the temples and houses have all been destroyed. We can read about these pictures in ancient writings. And we know that the Greeks were just as proud of their great painters as they were of their architects and sculptors. Fortunately, however, we have lots of Greek painted pottery (or "vases," as we call them, although they were made to hold wine or oil or water, not flowers). These vase paintings are often very beautiful, but of course they are much simpler than the large pictures were. From them we can get at least an idea of what the lost wall paintings must have been like.

In plate 9 you see the top part of a very early vase, from the eighth century B.C. Most of the forms are made up of triangles and squares, and everything is fitted into such a tight pattern that it takes us a while to realize that this is a scene of mourning: in the middle, the dead man is stretched out on a simple bed, and there are long lines of people on both sides, wringing their hands or tearing their hair in sorrow. How different this is from the Egyptian paintings, where nobody ever betrays his emotions. Here for the first time we find a picture of people not only *doing* things but *feeling* things. This shows us that the Greeks, from the very beginning, were much more interested in the living than in the dead. To them, life was an exciting and glorious adventure, not just a time to prepare for death. The dead, they thought, were only shadows whom nobody had to fear.

Our next vase (plate 10) was made about 530 B.C., in a style called Archaic, to distinguish it from the earlier, Geometric style. It is painted in black and dark red against the natural clay color of the vase. The lines inside the figures are made by scratching away the paint with a needle. Exekias, the artist, shows us the hero Achilles slaying

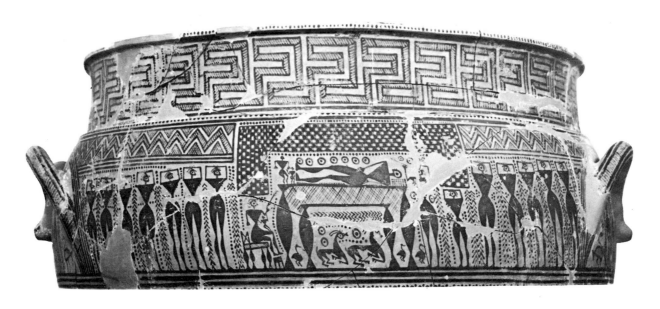

9. *Mourning Scene.* Painting on upper part of a vase from Attica. Geometric, eighth century B.C. Metropolitan Museum of Art, New York

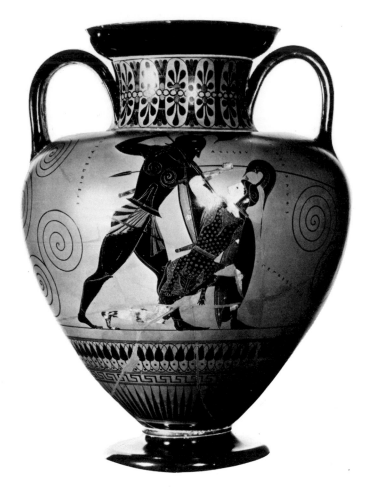

10. Exekias. *Achilles Killing Penthesilea*. Black-figured vase painting.
Archaic, about 530 B.C. British Museum, London

the Amazon queen Penthesilea. The Greeks believed that the legendary heroes of
old possessed godlike qualities, and were braver and stronger than the people of their
own day. Achilles himself was the son of the ocean-goddess Thetis and the hero Pe-
leus. The gods of the Greeks behaved very much like a family of human beings—they
quarreled among themselves or played jokes, and sometimes fell in love with mortals.
The two figures on our vase are a bit stiff in the joints, because the Archaic artist
was still using pretty much the same rules as the Egyptian painters. But they are also
full of energy and spirit, and that is exactly what the Egyptian painters had left out
of their pictures.

In the hundred years that followed, the Greek artists concentrated more than ever
before on facing the problems of this world instead of the next. They soon discarded
the age-old painting rules that the Egyptians had so carefully worked out, which had
dominated art for thousands of years. Look at plate 11, a painting in the middle of
a broad cup, made about 490 to 480 B.C. Here the lines are no longer scratched in.
They are drawn directly on the red clay of the vase with a brush, so that they flow
more gracefully and smoothly. The artist left the figures red and filled in the spaces
between them with black.

But the most remarkable thing about these lines is that they somehow make the
figures look round and natural, rather than flat. If you compare this painting with
that on the earlier vase in plate 10, you will see why. In *Achilles* we still find the old

11. The Foundry Painter. *Lapith and Centaur*. Center portion of red-figured vase painting.
About 490–480 B.C. State Collections of Ancient Art, Munich

combination of front and side views, but the scene in the circular picture is drawn almost the way it would actually look from where we stand. The body of the centaur, for instance, is strongly foreshortened, with overlapping arms and forelegs. But for exactly this reason we get the impression that the entire figure reaches back into space instead of sticking to the surface of the picture.

Plate 12 shows an example of what we call the Classic style, and is even more freely drawn; the figure is rounder than ever. The painter has sketched her on a white surface, almost as if he were working on a piece of paper, and the picture does indeed look much more "modern" than those we have seen before. The graceful young woman, sitting with such ease and assurance, makes us feel completely at home. We must not think, however, that she is meant to be a portrait. The Classic Greek artist was not yet interested in particular people, with all their personal imperfections; he preferred to make all his figures as beautiful as he could—he idealized them.

Only in later times, when Greek art had spread to all the countries around the Mediterranean Sea, do we find real portraits, such as the very fine one in plate 1. It comes from Egypt, about the third century A.D., but its style and technique are Greek. The picture is done on a wooden panel, and the colors are not mixed with water, as in all the paintings we have seen so far, but with hot wax. This makes a thicker, creamier kind of paint, which allows the artist to model his forms by blending light and dark shades of color right on the panel.

21

How Painting Began

The man who painted our portrait has done a wonderful job of modeling; that is one reason why his work looks so three-dimensional, so solid and real. But our painter also had a special feeling for all the little things that make this boy's face different from anybody else's: the stubby nose, the square jaw, the small, curved mouth, and the dark, shiny eyes. Of course the picture has style, too—otherwise we could not tell it from a snapshot—but we find it difficult to say just what this style is, since everything seems so fresh and natural to us. If we did not know that our picture was done more than seventeen hundred years ago, we might well think that it was painted only yesterday.

The technique of painting with wax could be used not only on wooden panels but also on the walls of houses. However, the favored technique for mural painting in ancient times was a method called "fresco," which means that the artist worked with watercolors on the freshly applied, moist plaster. The Romans were particularly good at this, as we know from the many murals that have been dug up among the ruins of their towns.

In the fifth century B.C., Rome was a small city-state like Athens, but the Romans had a much greater talent for government and politics than the Greeks. Their state grew bigger and more powerful as time went on, until it became a mighty empire that stretched all the way from England to Egypt and from Spain to Southern Russia. Although they had conquered the Greeks as early as the second century B.C., the

12. THE ACHILLES PAINTER. *Seated Woman*. Portion of a vase painting. Classic, about 440–430 B.C. State Collections of Ancient Art, Munich

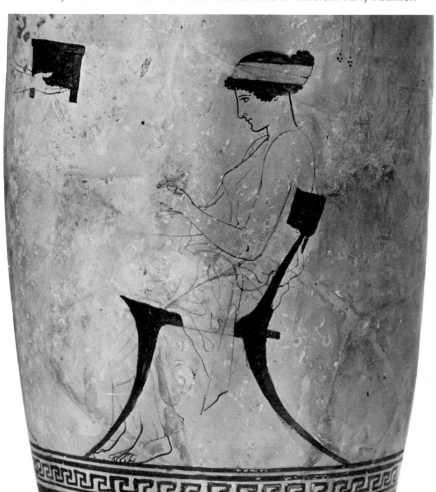

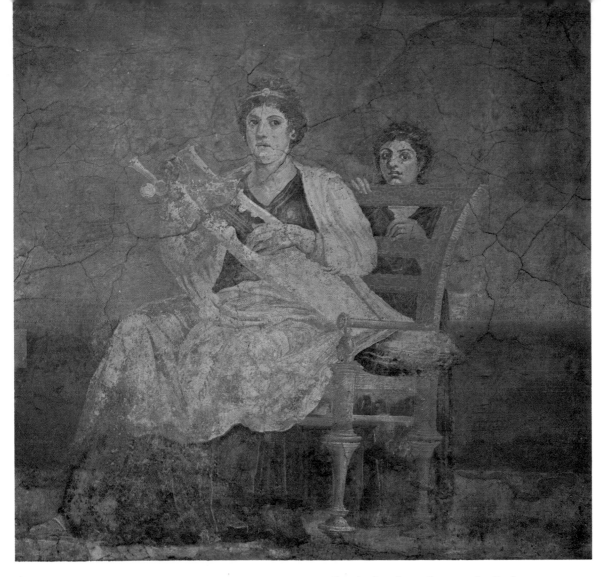

13. *Lady Musician and Young Girl*. Roman wall painting from Boscoreale, Italy.
First century B.C. Metropolitan Museum of Art, New York

Romans always had a great respect for Greek art, so that many of their own painters were influenced by the Greeks.

If we put some of the Roman pictures together with Greek vases, we can get a better notion of what the lost masterpieces of Greek wall painting must have looked like. In plate 13 you see such a Roman mural, taken from a house in the small Italian town of Boscoreale, near Naples. It was done less than a hundred years before the birth of Christ and is so large that the figures in it are just about lifesize. Still, it will remind you a good deal of the young woman on the vase in plate 11, which in reality is only a few inches tall.

The Roman lady still has something of the idealized beauty that we find in the Greek picture, even though she is not nearly as graceful. At the same time, she seems more real than the Greek woman, and not only because of the rich color and the careful shading. Her face, with its strong nose, looks as if it might be a portrait, and the little girl behind the chair could be her daughter. Roman painters often combined the real and the ideal in this fashion. It is hard to say how much they took from the Greeks and how much they invented, but in any case they are important to us because through their work the Greek style of painting was kept alive so that it could be handed on to the artists of the Christian era.

23

When we think of the many countries and the different kinds of people that came under Roman rule, we cannot help wondering how the Romans ever managed to hold their empire together. It must have been an almost impossible task. Fortunately, the Romans were too wise to rely on military force alone. After they had conquered a country, they made the people into "Romans" of a sort by teaching them Roman ways and even allowing them to become Roman citizens, with rights and duties fixed by law. There was one thing, however, that the Romans failed to do: they did not give the people within the Empire a common religious faith. The official Roman religion was like that of the Greeks, but the Romans never insisted that everybody had to accept it. All they required was a formal sacrifice every year to the emperor, who was to them a kind of hero-god like the Greek Hercules. For the rest, the Greek gods, the Egyptian gods, and all the other local gods were allowed to compete with each other; and since there were so many of them, nobody really knew *what* to believe in.

Such confusion was all very well as long as the empire was stable and peaceful, but when things began to go badly people felt a great need for the comfort and assurance that comes from a strong faith. It was then that they turned to the followers of Jesus Christ, the group most zealous in offering such a faith to the rest of the world. By the time the Empire was ready to collapse, Christianity had won out over all the other religions, and the Christian Church was well established.

Jesus Christ was born among the Jews, who had long believed in a single God while their neighbors worshiped many different gods. God, as the Jews thought of Him, was all-powerful; He had created the entire world and ruled over everything. All men were His children, but He had a special concern for the Jews, His chosen people, to whom He had made known His will in the form of laws or commandments. These laws, written down in the Old Testament, told men exactly how to behave toward each other if they wanted to lead good and worthwhile lives. This was a great and new concept: that God is just, and that the only way to please Him is by obeying His commandments.

Jesus, too, accepted the laws of the Old Testament. But He said that to observe these laws was less important than to love God, because God was filled with kindness and mercy for all men, even those who broke His laws. Jesus also believed that we must be as kind and forgiving to other people as God is to us. His own life, and His death on the Cross, as told in the Gospels of the New Testament, give us a perfect example of what He meant by this. To His followers, Jesus was the Son of God, the Saviour whose coming had been predicted by the Prophets in the Old Testament. They believed that God had sent Him in order to redeem mankind; that those who placed their trust in Christ would rise after death and live forever in Paradise; and that God offered this hope not only to the Jews but to all races and nations, to rich and poor alike.

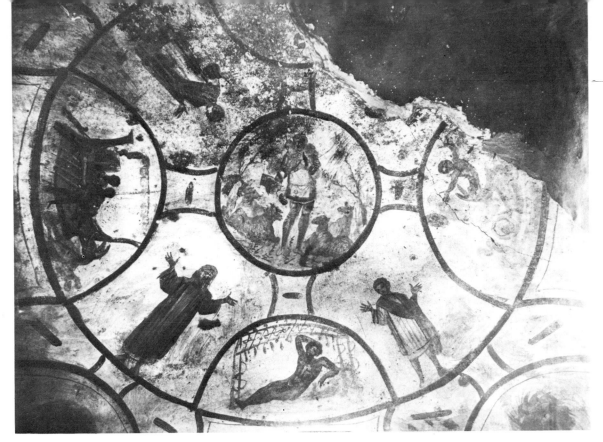

15. *Christ as the Good Shepherd, and Other Scenes*. Painted ceiling.
Early third century A.D. Catacomb of Saints Peter and Marcellinus, Rome

EARLY CHRISTIANS AND BYZANTINES

This last part of their faith explains why the followers of Jesus were so eager to spread their message everywhere. Soon after His death, they went to different parts of the Roman Empire. There they taught the new religion and formed the earliest Christian congregations, or churches. The most important church was in Rome; and in Rome, too, we find the first pictures by Christian artists. They were painted on the walls of long underground passages called catacombs, where the Early Christians buried their dead. Plate 15 shows you the remains of a ceiling decoration from such a catacomb, done about two centuries after the death of Christ. Its style is borrowed from Roman painting, but the figures in it are simpler and more sketchy; they also look a bit stiff, and seem to cling to the white background. Obviously, our artist was not much interested in modeling or foreshortening.

We can tell from this that the Early Christians even then had an outlook on life quite different from that of the believers in the Roman religion. Their thoughts were centered on the Saviour and on the life hereafter, rather than on their own strength or on the glories of this earth. Thus the beauty and power of the human body, which had been so important in Greek and Roman art, no longer held much meaning for them; instead, they wanted pictures that would show the power and glory of Christ, and tell of His mission on earth.

The Early Christian painter could not do this directly. He could only hint at it by using symbols—that is, figures or signs that stand for something which we cannot see. The picture in the middle of the ceiling is such a symbol; it shows a shepherd and his flock, but it stands for Christ, the Good Shepherd of men's souls. Since everything depends on Christ, the other scenes are arranged around this center like the spokes

27

of a wheel. They form a big cross, the simplest and most general symbol of the new faith. The standing figures represent the members of the Church, with their hands raised in prayer, pleading for help from above. In the four half-circles our artist tells the story of Jonah, from the Old Testament. Jonah had gone on a boat against the wishes of God, so the sailors threw him into the sea and a whale swallowed him. You see this in the scene on the left (the whale is shown as a kind of sea monster). On the right, the whale is letting him out again, because Jonah had prayed to God while he was inside the big fish. At the bottom, he is back on dry land, meditating about the mercy of God.

To the Early Christians, this story meant that they, too, would rise from the dead through the power of God, just as Jonah had risen from the whale. And they needed to be reassured, for they were having quite a hard time themselves. Still, more and more people joined them, so that by the fourth century even the emperors were Christians. Not long after this, Christianity became the official religion of the Roman Empire, and when that happened Christian art, too, began to take on a more official look. But by this time the western part of the Empire was falling to pieces, and the capital had been moved in 330 A.D. from Rome to Byzantium, in eastern Greece. The official Christian style of painting has been called Byzantine after that city, whose modern name is Istanbul.

The Byzantines decorated their churches with mosaics. These were made with little pieces of colored glass and are not paintings at all, but they carried on the tradition of ancient painting. *The Parting of Lot and Abraham* (plate 16) was probably

16. *The Parting of Lot and Abraham*. Wall mosaic. About 430 A.D. Church of Santa Maria Maggiore, Rome

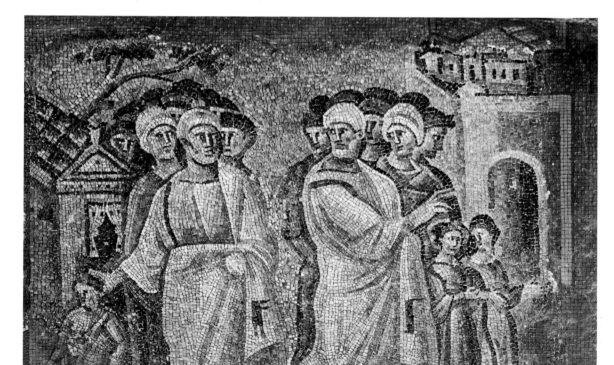

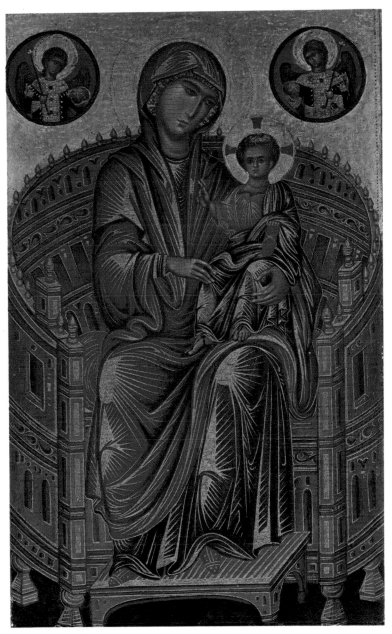

17. *Madonna and Child Enthroned.* Byzantine, about 1200.
National Gallery of Art, Washington, D.C.

taken over from another kind of painting, an illustrated manuscript of the Old Testament (see page 28). It is one of a long series of scenes, the oldest we have, showing the history of Salvation. On the left, Abraham is taking his little son Isaac, who will later be saved by the Lord, and the rest of his family away from Sodom, the evil city. But on the right we see Lot with his wife and daughters, who stay in Sodom and will suffer the vengeance of God. To the artist the word of the Scriptures is a living reality, not just something that happened long ago. Instead of simply telling us a story, he wants to reveal the working of the Lord's will, so he reduces the scene to a kind of artistic "shorthand." By separating the two groups so sharply, he contrasts the way of righteousness with the way of sin, making the message "loud and clear."

The Byzantine style of painting lived on, without any really vital or important changes, for a very long time. The *Madonna and Child* in plate 17—that is, the Virgin

The Middle Ages

Mary with her son, the Infant Christ—probably dates from around 1200, but it would look much the same if it had been painted a few centuries earlier or later. It is done on a wooden panel, like the portrait of the boy in plate 1, and the subject may remind us of the lady with the little girl in plate 13, but these comparisons only show us how different it is from Roman or even Early Christian painting. The Byzantine artist did not think of the Madonna as anything like an ordinary, human mother. To him she was the Queen of Heaven, far removed from everyday life and beautiful beyond any man's imagination. And he has painted her the way he *felt* about her: not as a woman of flesh and blood, made up of solid, round forms, but an ideal figure bathed in the golden light of heaven.

THE EARLY MIDDLE AGES IN THE WEST

Meanwhile, western Europe had been invaded by warlike tribes from the north and east. They conquered the Roman armies and made independent local kingdoms of the various provinces of the Empire, mixing through intermarriage with the people they found there. The nations of western Europe as we know them today—the English, the French, and the rest—all got their start in this melting pot. But first the tribes had to be taught about Roman civilization and about Christianity. They were now the heirs of everything that had been achieved by the older nations around the Mediterranean Sea, and there was a great deal they had to learn.

During this troubled time, which lasted for many centuries, the Church was the only stable institution that remained in western Europe. The task of spreading both faith and education fell to the monks—devoted religious men who lived together under strict discipline in special communities. The monks, however, were not only priests and teachers. From the fifth to the twelfth century—that is, for most of the period we now know as the Middle Ages—they were also the leading artists and craftsmen.

In those days almost every monastery had a workshop for making copies of the Bible and other books. This was done by hand, since printing was yet to be invented. The monks did not even know about paper; they wrote on vellum, a material made from the skin of calves, which was much more expensive but also a great deal tougher. Medieval books—or manuscripts, as they are usually called—were meant to last for a long time, and many of them are still in fine shape. The writing shops also included painters whose job it was to illuminate—to "brighten"—the manuscripts with pictures and ornament. These miniatures (from "minium," a red pigment) were done with marvelous care. For a long time they were the most important kind of medieval painting, and the best of them can stand comparison with any mural or panel picture.

It is not surprising that the monks took manuscript painting so seriously. After all, their faith was based on the Bible, which to many people is still simply "the Book." Since it contained the word of God, every copy of it was sacred, and to illuminate it,

to make it as beautiful as possible, was a way of worshiping God. Perhaps this idea will help us understand the manuscript page in plate 18, from the *Book of Durrow*, which was done by Irish monks in the seventh century. The words that go with this picture are those of the Gospels—the life of Christ written by the four Evangelists, Matthew, Mark, Luke, and John—but our artist has not tried to illustrate the sacred story. Instead, he has brightened up the page with a wonderful piece of ornament. These interlaced bands and weird, bandlike animals do not come from Early Christian art; they are borrowed from the native art of the tribes that had just settled in western Europe. And yet, the picture has a Christian meaning. You will notice that it is made up of a circle with a small cross in the center, with a wide square frame around it. This is our artist's way of showing the contrast between two different worlds: the frame, with its fighting monsters, stands for the cruel, dark world of the pagans, the unbelievers; while the circle is a symbol of the world under Christ.

CHARLEMAGNE

Our next miniature (plate 19) was painted around 800 A.D., at the time of Charlemagne, the first medieval emperor, who ruled over France, Germany, and most of

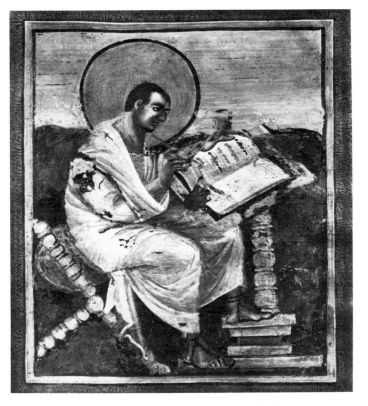

18. Page from the *Book of Durrow*.
Manuscript painting. Irish, seventh
century A.D. Trinity College, Dublin

19. *Saint Matthew*. Manuscript painting
from the *Gospel Book of Charlemagne*. Carolingian,
about 800 A.D. Kunsthistorisches Museum, Vienna

The Middle Ages

Italy. Charlemagne not only revived the idea of the Roman Empire in the West; he also wanted his people to learn everything they could about Roman civilization and about Early Christian art (because that, too, came from Rome). In the pictures of Charlemagne's own *Gospel Book*, there are no interlacing bands and tangled-up animals. Instead, we find the four Evangelists, carefully copied from Early Christian manuscripts. The one you see here is Saint Matthew. Everything about him—the powerful body, the bold head, and especially the use of shading and foreshortening—reminds us of Roman art. We might well mistake him for something painted many centuries earlier, if it weren't for the halo behind his head, which is a symbol to tell us that he is no ordinary author but a man filled with the spirit of God. (If you turn back to the Byzantine *Madonna and Child* in plate 17, you will see that everyone in the picture has a halo.)

But the Roman spirit of Charlemagne's time did not last. His empire was split up among his heirs, and reverted to being pretty much of a local power. In art, too, the native ornamental style of interlacing bands and animal forms came back after a few years. However, the painters also remembered what they had learned under Charlemagne—how to draw human figures and tell stories with pictures. So they began to combine the two styles into one. The result was a great new style, the so-called Romanesque, which flowered in the eleventh and twelfth centuries.

ROMANESQUE PAINTING

Despite its name, Romanesque is not at all Roman in spirit, although many of its forms are of Roman origin. Plate 20 shows you a fine example of Romanesque painting. It is the first page of the *Gospel of Luke*, from a manuscript illuminated in a French monastery soon after the year 1000 A.D. Look at the marvelous way the ornament, the text, and the illustrations are woven together here! There is so much to see that we hardly know where to start. The wide frame reminds us of the one in the *Book of Durrow*, but the interlacing bands have sprouted leaves and flowers, and the animals are less fierce and easier to recognize. At the top and bottom, we even have little hunting scenes. The large shape in the middle of the page is the initial letter "Q," again outlined with plant and animal forms. Inside the "Q" is a scene from the Gospel: the angel Gabriel announcing the birth of Saint John the Baptist to Zacharias. In the tail of the "Q" we see another sacred story, the birth of Christ.

These pictures show us that the Romanesque painter was quite familiar with the "official" Christian style of Byzantine art and respected its authority. When he designed the ornament of the outer frame, he simply invented his patterns as he went along, but for the sacred stories of the Bible he did not trust his own imagination. They had to be illustrated "correctly"—that is, the way they had been done by earlier artists—otherwise people might not recognize them. But if our artist has used Byzantine pictures as his models, he has not copied them very exactly. While his figures have a good deal in common with the Byzantine *Madonna* in plate 17, they are much

20. First page of the *Gospel of Luke*. Manuscript painting.
French, about 1000 A.D. Pierpont Morgan Library, New York

more forceful and expressive. In fact, they seem to be full of the same kind of energy and excitement as the plant and animal forms of the frame. This is what makes them Romanesque, and it also explains why the design of the whole page hangs together so well, despite its many different elements.

The story-telling power of the Romanesque style can be seen even better in our next picture (plate 21), a mural of the twelfth century from St. Savin in France. There used to be a great many such wall paintings in the churches of this period, but few of them have survived as well as this one. The subject here is the story of the Tower of Babel, from the Old Testament. This tower was to be a real skyscraper. The people who built it wanted to reach all the way up to heaven, to show that they were just as powerful as God. But they never finished it, because God suddenly made each of them speak a different language, so they could no longer understand each other. In our picture, the men on the right, led by the giant Nimrod, are carrying stone blocks for the masons on the tower. On the left you see God warning them to stop. The artist has put all this into a long, narrow strip, so that we follow the story as our eyes move back and forth across the picture. Perhaps this reminds us of the "strip pictures" of ancient Egypt (plate 7), and the Romanesque painter, too, shows us what he knows, not what he sees. But how intensely and dramatically he tells his story! In the Egyptian painting, all the figures seem to be standing still. Here, every line is in motion; people are beckoning to each other, straining under the load of the stones, arguing with God. We know right away that this is a great test of strength between ambitious men and their Creator, and we share the excitement the artist must have felt when he painted the picture.

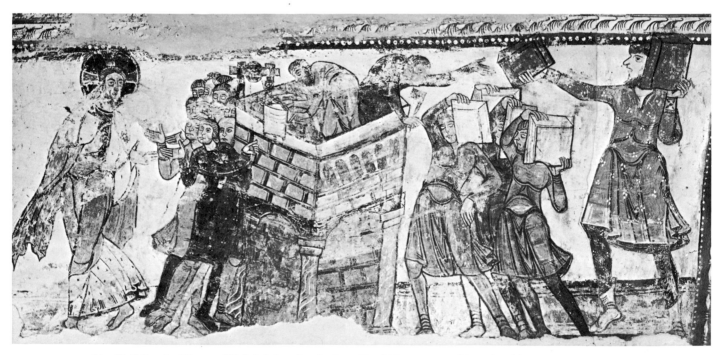

21. *Building the Tower of Babel*. Mural painting. Twelfth century. Church of Saint Savin, France

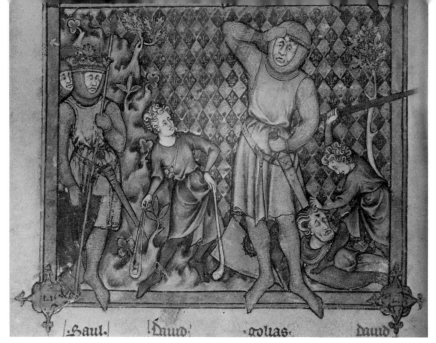

22. *David and Goliath*. Manuscript painting from the
Prayer Book of Philippe le Bel. French, 1295. National Library, Paris

THE RISE OF THE TOWNS: GOTHIC ART

During the earlier Middle Ages, the towns left over from the time of the Roman Empire became almost deserted, and those that had been newly founded remained small and quite unimportant. Most people lived in the open country, where they farmed the land belonging to the monasteries or the nobles. But from the twelfth century on, the towns began to grow again. More and more people left the countryside to become "burghers," free town-dwellers no longer bound to the land-owning overlords. This brought about a great change in medieval life. The burghers were skilled craftsmen and enterprising tradesmen, so that the towns soon became the centers of wealth, and of art and learning as well. Also, city life made people more independent and practical-minded. It opened them up to all sorts of new ideas, and gave them a greater interest in the world around them.

Out of this new spirit came a new style in art called the Gothic. It started in France about 1150 A.D. and spread from there to all the other countries of the Western world. The miniature in plate 22, from a prayer book dated 1295 A.D., will show you how very different Gothic painting is from Romanesque. It was done by a burgher, a professional manuscript painter in the city of Paris, rather than by a monk. The subject is the famous Old Testament story of the victory of David over the Philistine Goliath, but our artist has treated it as if it had happened in his own lifetime. The giant Goliath, in the center, and King Saul, on the left, are wearing the armor of medieval knights. But what really surprises us is the new interest in shading, which gives all the forms a softer, more natural look. While our picture as a whole has little depth, there is enough modeling here to lift the figures away from the flat pattern of the background, and the way their feet overlap the frame shows us that they are meant to be *in front of* the page, not just *on* it.

Another kind of painting that flourished in Gothic times was done on small pieces of colored glass, which were cut to shape and then fitted together with lead frames into large stained-glass windows. The Old Testament king in plate 14 is a detail from such a window, made in Germany around the year 1300 A.D. Here you see the same soft,

35

The Middle Ages

loopy folds of drapery as in the miniature of *David and Goliath,* but the difficult and limited technique of this art has made modeling almost impossible. Perhaps we should not think of stained-glass windows as pictures at all; they are really transparent screens whose beauty depends on the marvelously rich and brilliant color patterns. These windows were an essential part of Gothic architecture. In France, England, and Germany they reached such great size that the churches began to look like glass buildings, and there was little space left for murals.

GIOTTO AND ITALIAN PAINTING

Italy alone was an exception to this rule. There the churches kept their solid walls, and mural painting continued to be a great art for many centuries. But the Italians were different from the nations to the north in other ways as well. They had never quite forgotten that they were the heirs of the Romans and Early Christians, and they also knew much more about city life. Italy had wealthy and powerful medieval towns earlier than any other country, so that we need not be surprised to meet a particularly bold and "modern" spirit among Italian Gothic painters. The greatest of them all was Giotto, who was born in the city of Florence in 1266. He is the first painter in history who is as much admired today as he was during his own lifetime. We know that his works were considered something new and wonderful then; and since a good many of them have come down to us, we can find out for ourselves why he became so famous. Looking at his *Lamentation over Christ* (plate 23), which is one of a series of fresco murals in a private chapel in Padua, we feel at once that it is a large picture, not a miniature from some manuscript. This has little to do with the actual size— it's the bigness of the shapes that makes the painting seem so large. There is no fussy detail in these strong and simple figures. Their weight and roundness almost make them look like great rocks. We call such figures monumental, because they remind us of a stone monument, firmly set in place for all time.

Yet Giotto's people are full of human feeling. We share their sorrow over the death of Christ, whether we look at the weeping angels in the sky or at the mourners below. Through their gestures, and the expressions on their faces, they speak to us so clearly and simply that we ourselves become part of the scene. But there is something else that makes the *Lamentation* such a powerful work of art: its composition—by which we mean the way the figures and other forms are arranged inside the frame. When we look at story-telling pictures like the Romanesque mural or the Gothic miniature, our eye travels from one detail to the next. In the *Lamentation,* on the other hand, the large, simple forms and the strong grouping of the figures allow us to see the entire scene at one glance. Giotto has composed it the way a great stage director would put on a dramatic play in the theater. Even the scenery makes us think of a stage set; it leaves just enough room for the bulky figures, but the background looks flat. If we follow the foreshortened right arm of the Saint John, in the center, we can measure the actual depth of the "stage."

The Middle Ages

Before Giotto, Italian painting had been closely tied to the Byzantine style. If you compare his work with the Byzantine *Madonna* in plate 17, you will understand why he came to be remembered as the man who led Italian art back to natural forms. The painters in Siena, a town not far from Florence, had a similar aim but went about it another way. They "unfroze" the Byzantine style, so that it became more lively and realistic. Among the best was Simone Martini, who painted the small wooden panel of *Christ Carrying the Cross* (plate 24). The picture is done in tempera, a technique used

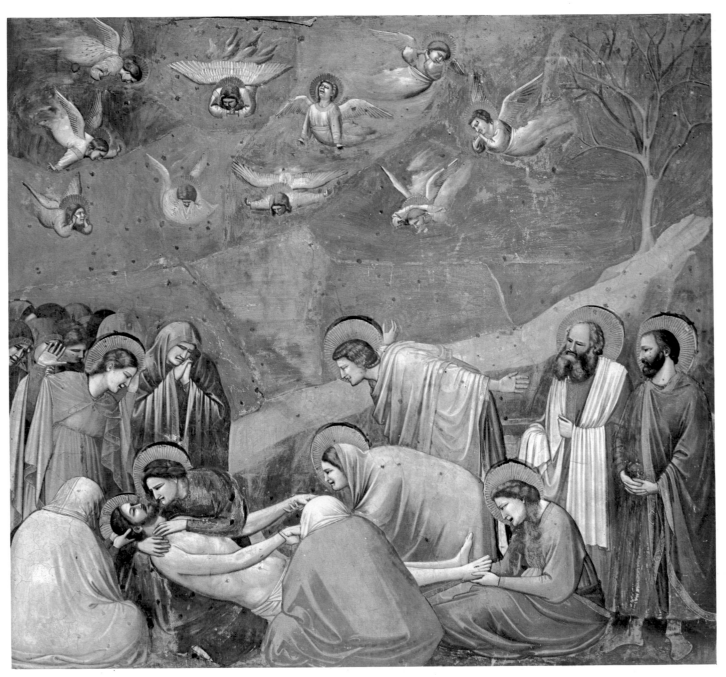

23. GIOTTO. *Lamentation over Christ*. Fresco. 1305–6. Arena Chapel, Padua

37

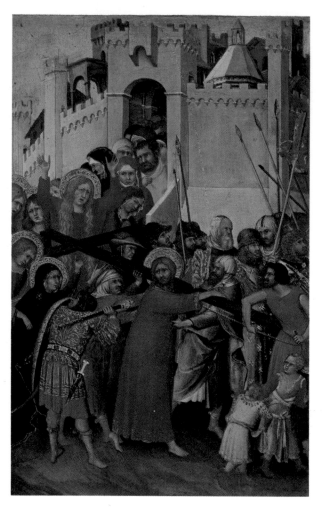

24. SIMONE MARTINI. *Christ Carrying the Cross.*
About 1340. Louvre Museum, Paris

for both miniatures and panels (the colors are mixed with egg yolk and water, making a thin, smooth paint that dries to a tough enamel-like film). The fine detail and the brilliant colors give tempera paintings a jewel-like quality very different from fresco paintings. Some of Simone's figures still remind us of Byzantine art, while others show the influence of Giotto in their bulk and expressiveness. Giotto's sense of drama is missing, to be sure, but Simone has a wonderful eye for all the little touches that bring the scene to life, such as the costumes or the pushing and pulling of people in a crowd, so that in some ways he comes even closer to reality. Notice how he has struggled to give depth to his painting: he shows us not only the people pouring out of the city in the background, but the city itself. The foreshortened view is a bit awkward still, but at least the picture space is no longer limited to a narrow foreground stage.

Simone Martini also became an important link between Italy and Northern Europe. He spent some years in the south of France, where he came to know French Gothic art while the French learned from him about the new Italian style. By the end of the fourteenth century, exchanges of this kind had become so frequent that there was no longer much difference between the Italian and the Northern painters. They all worked in a style which we often call "International Style" in order to stress their similarity of outlook.

The Middle Ages

INTERNATIONAL STYLE

The next three pictures date from this period, the International Style, which lasted only until about 1420. The panel in plate 25 was painted in the 1390s by Melchior Broederlam for his patron, the Duke of Burgundy. It is one of a pair of wings that fit over an altar shrine (this explains its odd shape). On the left side, where the Christ Child is being presented to the High Priest in the Temple, we see how much Broederlam has learned from the Italians about painting architectural space. His temple looks a bit unreal, as if it were a sort of cage built around the figures, yet it has a good deal of depth. There is Italian influence, too, in the heavy-set figures. The soft, flowing folds of the costumes, on the other hand, remind us of the *David and Goliath* miniature, except that they are richer and more complicated. Such ample garments were popular among the artists of that time, since they made the figures look bulkier. On the right we see the Holy Family—Mary, Joseph, and the Infant Christ—fleeing into Egypt. The softly shaded rocky slopes, the trees and flowers done with such loving

25. MELCHIOR BROEDERLAM. *Presentation in the Temple and Flight into Egypt*. Wing of an altar. About 1395. Museum of Fine Arts, Dijon

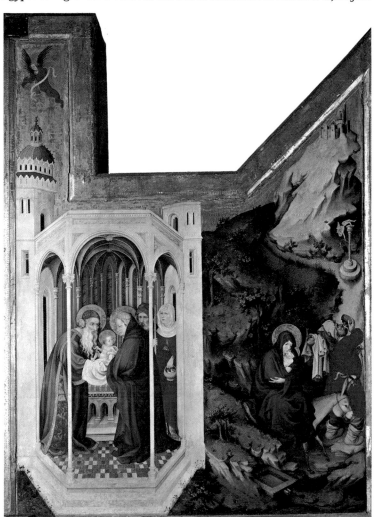

It is always hard to establish with any certainty the exact moment when something new began. The calendar may tell us that March 21 is the first day of spring, but if we are asked about the *real* start of the new season we cannot pin it down as neatly as that. It is just as hard for us to say when the modern age began. We do know, however, that the Middle Ages came to an end sometime between the fourteenth and the sixteenth centuries—in some places this happened much sooner than in others—and that the Western world entered a new and vital era called the Renaissance. Gothic art, with its growing interest in nature and its more human approach to religious stories, has shown us that people's outlook on life was beginning to change even earlier.

By about 1420, this curiosity about animals, plants, and people had become a tremendous urge to explore the whole world and everything in it. People were less and less willing to take things on faith; they wanted to ask their own questions and look for themselves. Bold seafarers set out for unknown lands and came back with reports that helped to fill in the blank spots on the map. Columbus, who discovered America in 1492, was one of these. Other men explored the field of mechanics and invented important new techniques, such as printing (about 1450), which made books so cheap that many more people could afford them than before. And the artists, too, turned into explorers. Simply by taking a fresh look at things, they discovered that the world around them was full of beauties and wonders that no one had been aware of before. In fact, they often knew more about the workings of nature than the scientists of their day, because they had learned how to use their eyes, while the scientists still relied on medieval book-learning.

LATE GOTHIC ART: THE VAN EYCKS

The Italian and the Northern painters broke away from the International Style at the same time, but they did not do it in the same way. That is the reason we use different names for their work. Italian fifteenth-century art is called "Early Renaissance" and that of the Northern countries "Late Gothic"—even though both styles have a good many things in common. Late Gothic painting had its start in the wealthy towns of Flanders (or Belgium, as it is called today). The great masters in Bruges and Brussels were so famous that the new style was known all over Europe simply as "Flemish." The earliest of these great discoverers were the brothers Hubert and Jan van Eyck. One or the other of the two probably made the two small pictures in plate 28. These are painted in a complicated new technique the Van Eycks had helped to develop; we still don't know exactly how they did it, but apparently they used one or more coats of very thin oil paint on top of tempera. The oil paint would let the colors underneath shine through, producing softer shades and a richer blending of tones than one could get from tempera alone. The tall and narrow shape of the panels in-

dicates that they are the wings of a small altar; they probably flanked a larger center panel which has been lost.

The left-hand wing shows the Crucifixion. We seem to be looking down at the scene, as if we were watching it from a position in mid-air. This was the only way the Van Eycks could tell the story of the Crucifixion as clearly as they wanted to. If they had put us down on the ground among the bystanders, they would have had to make the figures in the foreground so large that our view would be cut off. Perhaps it has struck you that despite the milling crowds of people there is hardly any drama or action in the picture. The Van Eycks seem to have paid just as much attention to all the things that are *not* part of the story—the rocks on the ground, the details of the costumes, the landscape behind the crosses—as to the human figures. But this does not mean that they were any less religious than the painters of the Middle Ages. If you could ask them about it, they would probably say that God had created not only man but the rest of the natural world as well; why then should a pebble or a blade of grass be less of a miracle, less worthy of our respect, than man himself?

In *The Crucifixion* we are shown a piece of the real world, as if a window had been made of the picture. And why are we so convinced of this? Because the Van Eycks had made a great discovery: what we see in real life depends on how the light is picked up by the things we are looking at, and also on the air that is between these things and ourselves. Some surfaces, such as rough rocks or trees, swallow up most of the light that hits them, while others, such as polished metal or water, make it bounce back, like a mirror.

What the Van Eycks found out about air was equally new and important. We all know that in foggy weather the air sometimes gets so "thick" that we can see only a few feet ahead. But the air is never completely clear. Even on the brightest days it acts like a hazy screen between us and the things we are looking at; the farther away these things are, the dimmer and grayer they seem. The Van Eycks were the first painters to understand this clearly. In *The Crucifixion* every form is both "air-conditioned" and "light-conditioned," so that all the details fall into place just as they do in nature. What holds the scene together, then, and makes it so different from all the pictures we have seen before, is a new kind of order based on the behavior of light and air.

While the story of the Crucifixion could be told in terms of the natural world, the subject of the right-hand wing had to be made up entirely from the artist's imagination. It is the Last Judgment: at the end of time, so the prophecy goes, all the dead will rise from their graves to have their deeds judged by God. We can see them coming out of the ground and the ocean in the middle of the picture. Above them is the Lord, surrounded by the blessed souls who have been admitted to everlasting life in Paradise. Down below, the sinners who have been condemned to living death in Hell are being tortured by devilish monsters. Into this Hell, which has the awful reality of

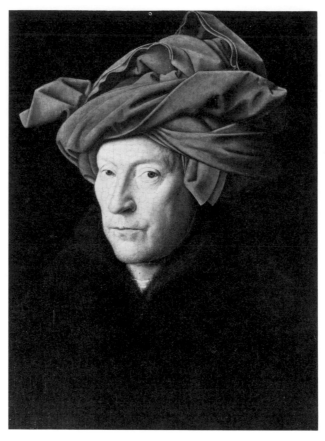

29. JAN VAN EYCK. *The Man in the Red Turban.*
1433. National Gallery, London

a nightmare, the Van Eycks have poured all the violent action, all the expressiveness they seem to avoid everywhere else. Here we see that the new painting rules can be applied even to a subject as "un-natural" as this; far from stifling the artist's imagination, they only help him to make these fantastic demons more believable, and the pains of the damned more heart-rending, than ever before.

In medieval painting there had been no real portraits, because nobody had thought it worthwhile to record the things that make one person look different from another. Now, in the fifteenth century, people wanted portraits they could recognize, and the painters learned very quickly how to do likenesses of this kind. *The Man in the Red Turban* (plate 29) was done by Jan van Eyck in 1433. We do not know the sitter's name, but it may very well be the artist himself. (There is a slight strain about the eyes, as if the man were gazing into a mirror.) Here again we marvel at the rich play of light and shade, which gives us the "feel" of every surface, from the stubble of beard on the chin to the crinkly fabric of the turban. Yet, strangely enough, we learn very little about the character of this man: his face is as calm, as undisturbed by thoughts or feelings, as the landscape in *The Crucifixion.*

ROGER VAN DER WEYDEN

The next picture (plate 30) dates from about 1440. It is the work of another great Flemish master, Roger van der Weyden, who had been strongly influenced by the

46

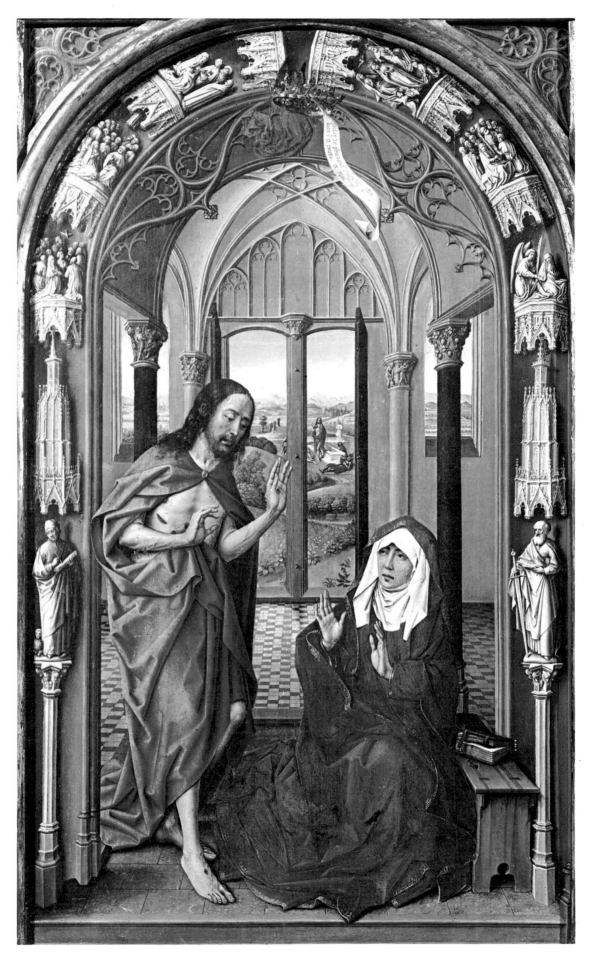

30. ROGER VAN DER WEYDEN. *Christ Appearing to His Mother*. About 1440.
Metropolitan Museum of Art, New York

discoveries of the Van Eycks. Roger's main concern, however, was not the world around us but the world within us—he was the great explorer of human feeling in religious art. The panel shows Christ appearing to his mother after He had risen from the grave. The Virgin Mary has been reading her prayer book; suddenly, she feels the presence of her Son and turns her grief-stricken face toward Him, while He raises His hands as if to reassure her. There is an air of deep sadness and suffering about these two figures that immediately touches our heart, because their feelings seem as real to us as the painted architecture or the fine, airy landscape in the background. The setting may strike you at first as rather too elaborate, but if you study it more closely you will find that almost every detail has a meaning related to the main figures: the stone carvings on the arched portal tell us about other events in the Virgin's life and in the distance we see Christ leaving His tomb while the soldiers on guard are asleep. This is perhaps the most astonishing thing about Late Gothic painting—how the natural world is made to contain the world of the spirit in such a way that the two actually become one.

OTHER LATE GOTHIC PAINTERS

It was Roger who made the new Flemish style known all over Northern Europe. Among the countless artists from neighboring countries who felt his influence, one was a Frenchman; his name has been forgotten and we know only one work by his hand, but that picture, painted in the years around 1470, is one of the most famous in all of Late Gothic painting (plate 31). It is called *The Avignon Pietà*, since it used to belong to a church near the city of Avignon, in the south of France. "Pietà" is the Italian word for "pity," but it also has come to mean the image of the dead Christ in the lap of His mother. In our picture the Madonna is flanked by Saint John and Saint Mary Magdalene. The figure kneeling in prayer on the left is a portrait of the man who ordered the painting.

The *Pietà* does not tell a story; it is meant, rather, to make us share the silent grief of the Virgin by reminding us that a younger and happier Madonna once held the Infant Christ on her lap in much the same way. There are many things in our picture that recall Roger van der Weyden, but its design is very much simpler, and in this simplicity lies its strength. It has a "bigness" about it that makes us think of Giotto. And we may not be altogether wrong: Avignon is closer to Italy than to Flanders, so that our master might well have been touched by Italian art even though his *Pietà* remains entirely Late Gothic in feeling

At the end of the century, the most important French painter was again an artist for whom we have no certain name; we call him the "Master of Moulins." The young princess (plate 32) whose picture he painted about 1490 could not have been more than ten years old. We can tell by her elegant costume and by the castle in the background that she must be somebody important. Fortunately, our painter has not been overawed by her high rank; he shows her as a delicate and gentle little girl, perhaps

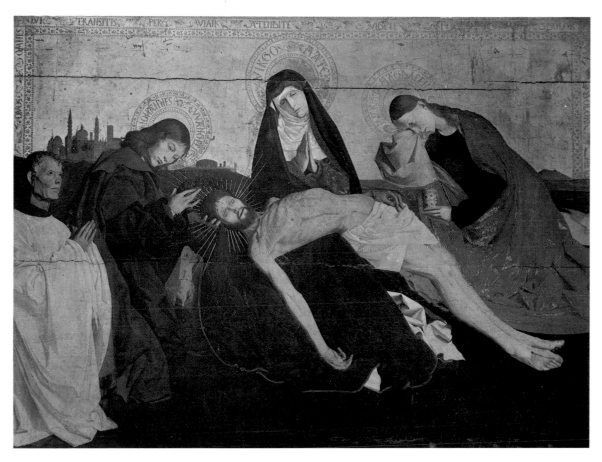

31. SOUTHERN FRENCH MASTER. *The Avignon Pietà*. About 1470. Louvre Museum, Paris

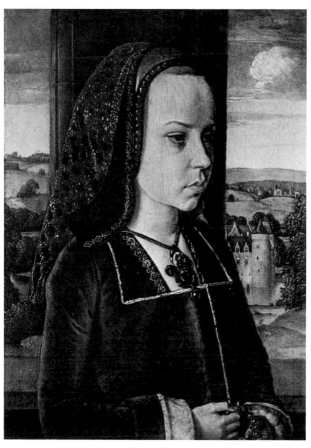

32. THE MASTER OF MOULINS. *A Young Princess.*
About 1490. Metropolitan Museum of Art,
New York (Robert Lehman Collection)

33. JEROME BOSCH. *The Ship of Fools*. About 1500. Louvre Museum, Paris

a bit too serious for one so young. Or could it be that the hint of sadness in her face is just another echo of the style of Roger van der Weyden?

Our next picture (plate 33) was painted by Jerome Bosch, an extraordinary Dutch master who seems closer to the Van Eycks than to Roger van der Weyden. Its soft, airy background will remind you of *The Crucifixion,* and the jerky gestures and excited expressions of the figures have something in common with the violent Hell scene of *The Last Judgment.* Bosch, too, shows us a kind of hell, but it is a hell of man's own making. His painting was inspired by a popular book, *The Ship of Fools.* It tells us that the world is full of silly people whose only aim is to have a good time. Instead of preparing for the day when God will judge their deeds on earth, they float through life as if it were a pleasure trip. And yet they don't seem at all happy, despite their frantic merry-making: in their greed they overeat, get drunk, and fight among themselves, while their ship is drifting toward dangerous waters. We can be quite sure that the journey will come to no good end.

MASACCIO AND THE EARLY RENAISSANCE IN ITALY

We may be amused by the Punch-and-Judy antics of Bosch's figures, but actually they show us a grim, even hopeless, view of human nature and of man's place in the world. In Northern Europe, as the Middle Ages came to an end, there were many people who felt the way Bosch did—lost, frightened, longing for a new faith to take the place of the old. But in Italy this mood was not so general. In fact, many Italians welcomed the new era as a rebirth, for that is what the word "Renaissance" means, and they were the ones who coined it. It was, they said, the rebirth of those powers of the human mind that had created the glories of Greece and Rome. The thousand years since the death of Classical Antiquity they called the "Middle Ages," meaning "the time in-between" when little of real importance had been done in the arts. And for the style that had been brought into Italy from the North they invented the insulting label "Gothic," because they disliked it so. (The Goths were one of the tribes that had helped to destroy the Roman Empire in Early Christian times.) Today we no longer despise the art of the Middle Ages or look down on Gothic art as inferior, although we still use the same designations.

Naturally, of course, the Italians did not try to turn themselves into Classical Romans pure and simple. They certainly had no idea of giving up the Christian faith. Still, they believed that we ought to rely more on ourselves, instead of depending on God for everything. "Since the Lord has given us such remarkable powers of mind, and such a beautiful world to live in," they asked, "is it not our duty to make full use of these gifts?" The Ancients, they felt, had in many ways done a better job of this than anybody else, so there was a lot to be learned from them. But they always thought of themselves as the rivals of Classical Antiquity, not as mere imitators; they took from it what they needed, and left the rest alone.

Florence, the home town of Giotto, can be considered the birthplace of Renais-

51

sance art. In the field of painting, the new style began and evolved from the work of Masaccio, a youthful genius who died about 1428 when he was barely twenty-eight years old. We have only a few paintings by his hand, but these are quite enough to show us that he was an even bolder explorer than were the Van Eycks. The fresco of *The Holy Trinity with Saint John and Saint Mary* (plate 34), which he painted about 1427, owes nothing to the International Style; we can tell from the monumental, bulky figures, and the "bigness" of the design as a whole, that Masaccio has gone back a full hundred years to pick up the style of Giotto. And yet we find a great difference between the two: Giotto's figures remind us of carved stones, while Masaccio's seem to be made of flesh and blood. But then Giotto was, after all, a medieval artist. When he painted a human figure, he thought only of what it would tell us, or how it would make us feel; he was not interested in putting it together the way such figures are put together in real life. Masaccio, on the other hand, tried to do exactly that. We might say that he wanted to do Giotto over again, but from nature. You will see what this means if you look, for example, at the Saint John and Saint Mary. Although they are wrapped in heavy cloaks, we can feel the shape of their bodies under the drapery, and this is something we haven't been able to do since we looked at the Roman mural in plate 13. Masaccio had never seen any paintings like that, but he worked in much the same way as the Ancient painters: he thought of the bodies of his figures first, and then put the clothes on them separately. In order to do that, however, he had to find out how clothes behave—what kinds of folds you get when you pull a cloak around your shoulders, or bunch it over your arm, or let it hang to the floor. This is why the draperies in the *Trinity* fresco have the natural flow of real cloth.

But Masaccio also needed to know about the forms underneath the drapery; and that was very much more difficult, for it meant that he had to relearn everything the Ancients had discovered (and the Middle Ages had forgotten) about the workings of the human body. A look at his Christ on the Cross will tell you how amazingly well he succeeded in this. The most remarkable thing about the figure is not just that every bone, every muscle is in the right place; it's the way all these details fit together. Masaccio realized that the body is like a complicated and finely adjusted machine, which will run only if all the parts are in working order. That is why all his figures look so strong and full of energy. If you turn back for a moment to the *Christ* by Roger van der Weyden (plate 30), you will find that there, too, the details are well observed, but the "working order" is missing; the joints seem stiff, the muscles weak, and the whole body makes us think of a wooden puppet dangling from invisible strings instead of firmly standing on the ground (at least, that is what Masaccio would probably have thought). Late Gothic figures never look as if they could do anything by themselves; Early Renaissance ones do, even when they are just standing still— or hanging from a cross.

The *Trinity* fresco also shows us another great discovery. Its architectural background is foreshortened according to a set of rules which we call scientific perspective. Earlier painters had used foreshortening of a sort, too, but they had done so in a

34. MASACCIO. *The Holy Trinity with Saint John and Saint Mary.*
Fresco. About 1427. Church of Santa Maria Novella, Florence

hit-or-miss fashion, without any rules to guide them. Only scientific perspective made it possible to get a clear and consistent picture of where things are in space, since it was based on mathematics and the exact measuring of angles and distances. In themselves, the new rules had nothing to do with art or imagination, and yet they were discovered by artists, rather than by scientists, because the artists of the Early Renaissance were so eager to get a firmer grip on the shapes of the natural world.

PAINTERS AFTER MASACCIO

While Masaccio's bold new style was greatly admired by his fellow artists, it took some time for his ideas to be fully understood. In many other Florentine pictures we can find echoes of the International Style as late as the middle of the fifteenth century. The round panel in plate 35, begun by Fra Angelico and finished by Fra Filippo Lippi about 1445, is an excellent example of this style. It shows the Magi—the three wise men or kings from the East—kneeling in adoration before the Madonna and Child. They have traveled a long way, accompanied by countless servants and animals, as befits their great wealth. You see this crowd pouring through the city gate

35. Fra Angelico and Fra Filippo Lippi. *The Adoration of the Magi*. About 1445.
National Gallery of Art, Washington, D.C. (Kress Collection)

on the left, but there seems to be no end to them, for the people coming down the mountain in the right background still belong to the same vast train. All this makes a wonderfully gay and colorful scene, crammed with fascinating detail; but we miss the order, the clarity and simplicity of Masaccio. Just take a look at the buildings—their lines are slanted in a curious, mixed-up way, without regard to scientific perspective. And the graceful peacock on the roof of the stable in the middle of the picture is much too big. On the other hand, we can feel the influence of Masaccio in some of the figures, such as the dignified Joseph standing next to the Madonna, or the partially dressed figures by the city gate.

Among the painters who were willing to follow Masaccio all the way, the greatest was certainly Piero della Francesca. In plate 36 you see part of a huge, elaborate fresco cycle he did about 1460 in the town of Arezzo, to the south of Florence. It shows the Roman Emperor Constantine, who has just become a Christian, at the

Explorers and Discoverers

head of his army; he is holding up a small white cross for his pagan enemies to see, and so great is the power of this symbol of faith that they flee without a fight. (Their flight fills the right-hand half of the fresco, not shown in our plate.) Piero has not given his soldiers the kind of costumes and arms they actually had in Constantine's day, even though he could have found out about these things by studying Roman art if he had wanted to. Yet every shape in the painting has so much firmness and clarity that we may well compare Piero's style to the finest Classical works of the Ancients. No other painter ever came as close as he did to the monumental spirit of Masaccio.

One of the secrets of Piero's success is that he analyzed the shapes of the natural world according to the laws of perspective. In fact, he wrote a famous book illustrating these rules for painters. But Piero was much more than a "scientific" artist. He had a splendid feeling for design and great power of expression, otherwise our picture would not look so vigorously alive. And he also understood the new order of light and air which we first found in the works of the Van Eycks. The brisk, clear morning air, the sunlight glistening on the shiny armor—these tell us as much as the forms themselves about the sense of adventure, the wonderful self-confidence of the age of "rebirth."

36. Piero della Francesca. *The Battle of Constantine* (portion). About 1460. Church of San Francesco, Arezzo

OTHER INFLUENCES ON EARLY RENAISSANCE PAINTERS

So far we have seen no direct influence of Classical art on the painters of the Early Renaissance. This is not really so strange: while the fifteenth century was well acquainted with Ancient architecture and sculpture, it knew almost nothing about Ancient painting. Still, our painters *did* learn from Classical art, by taking ideas from Ancient sculpture and fitting them into their own work. In plate 37 you see how this could be done. It shows the *Victorious David*, painted on a leather shield by Andrea del Castagno soon after 1450. While such a shield was meant only for display, not for actu-

37. ANDREA DEL CASTAGNO. *The Victorious David*. About 1450–55. National Gallery of Art, Washington, D.C. (Widener Collection)

38. *Fleeing Warrior*. Ancient sculpture. Uffizi Gallery, Florence

39. ANDREA MANTEGNA. *The Crucifixion.* 1456–59. Louvre Museum, Paris

al fighting, its owner wanted everybody to know that he should face his enemies as bravely as David. In our picture, David has already won out over Goliath, but he is again wielding his sling and challenging all comers. Perhaps you will remember the Gothic miniature (plate 22), in which David looks like a child who could never have done what he did if his hands had not been guided by the Lord himself. That was the medieval way of looking at the story. Castagno obviously thought otherwise: to him, David was an athletic young man whose courage came from God but whose strength and skill were his own. He wanted to show his hero in a fighting pose, and this is why he turned to Classical sculpture for help, since the Ancients had known a great deal more about the human body in action than he did. The statue in plate 38 will show you how Castagno has followed the outlines of his Ancient model even to the wind-blown drapery. Curiously enough, however, the Classical warrior is not a heroic figure at all; in fact, he is running away and his hand is raised for protection. Castagno has changed the meaning of the pose from fear to defiance.

Castagno's *David* seems much less solid and bulky than figures by Masaccio or Piero della Francesca. His forms are more graceful, tense, and nervous. We find a similar style in our next picture (plate 39), a dramatic *Crucifixion* panel by Andrea Mantegna, who was one of the first, and also the greatest, of the Early Renaissance masters in North Italy. He came from the town of Padua, near Venice, and it is likely that he was influenced by Castagno, who had done some murals in Venice during Mantegna's youth. His figures look even more strained than Castagno's *David*; the tautly stretched Christ and the mourning group under the Cross to the left are so in-

57

40. FLORENTINE MASTER. *A Young Lady.*
About 1460. State Museums, Berlin

tensely expressive that they make us think of Roger van der Weyden and *The Avignon Pietà*, while the deep, airy background landscape reminds us of the Van Eyck *Crucifixion* in plate 28. As a North Italian, Mantegna understood Late Gothic painting better than the Florentine masters did, but he was also a keen student of scientific perspective. Instead of letting us float above the scene, the way the Van Eycks had done, he gives us a front-row seat, as it were, on a level with the figures in the picture, so that we are far more directly involved with the tragic story before our eyes.

The difference between Late Gothic and Early Renaissance shows up particularly well in the field of portrait painting. We are not sure who painted the elegant young lady in plate 40—an important Florentine master, certainly, of the time around 1460—nor do we know her name, but she must have been one of the famous beauties of her day, and the picture is quite frankly meant to make us admire her beauty. One might almost call her a very refined fashion model, who knows her own good looks and is proud of them. Our artist has given her such a self-assured air that the *Young Princess* by the Master of Moulins (plate 32) seems downright timid by comparison.

In plate 41 you see another kind of portrait. This picture of an old man and his grandson was probably ordered by the little boy's father, and for much the same reason that today we take family snapshots—to remind us of people we love. Domenico Ghirlandaio, who painted it in Florence about 1480, admired the realistic style of the Flemish masters. He has recorded the wrinkles, the warts, the diseased nose of the old man exactly as he saw them. But there is also something here that we don't find in

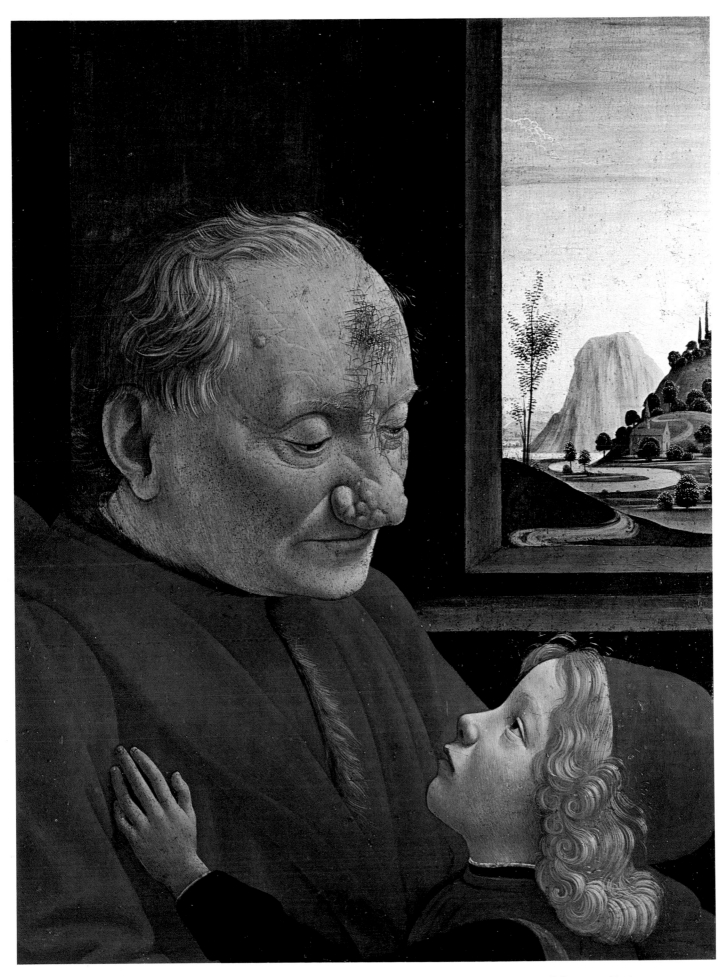

41. DOMENICO GHIRLANDAIO. *An Old Man and His Grandson*. About 1480. Louvre Museum, Paris

Late Gothic portraits: the picture tells us not only what the old man looked like but what kind of a person he was. We would never think of comparing this face to a landscape (as we did with *The Man in the Red Turban* by Jan van Eyck in plate 29), because it is alive with the glow of love and tenderness. And the little boy looks up to his grandfather so trustingly that we, too, no longer mind the ugly, swollen nose and think only of the warm human feeling that links these two people.

The last two pictures in this chapter bring us back once more to the idea of the "rebirth of antiquity," since the subjects of both of them are taken from the religion of the Greeks and Romans. Needless to say, the Church frowned on such pagan stories, and yet we find more and more of them toward the end of the fifteenth century. Did the artists who painted them, and the patrons who owned them, actually believe in the ancient gods? Certainly not. Sandro Botticelli, for instance, who did the famous *Birth of Venus* in plate 42, was a deeply religious man; neither he nor anybody else in Florence accepted the goddess of love as "real" the way they accepted Christ or the Madonna. If we want to understand this picture, we must think of it as a sort of poetic dream where the "heavenly" beauty of this "celestial" Venus leads us to the "divine" love of God. Born of the sea like a shimmering pearl, she stands not only for "rebirth in God" through baptism, but also for that "rebirth of mankind" which was the great hope of the Renaissance. And she looks as frail as a dream, too—pale, delicate, without weight or bulk, she bends like a reed in the gentle breeze from the mouths of the two wind gods, who are made to look like angels. How solid and powerful Castagno's *David* seems, compared with these gossamer creatures!

Our other "pagan" picture (plate 43), painted by Piero di Cosimo shortly before

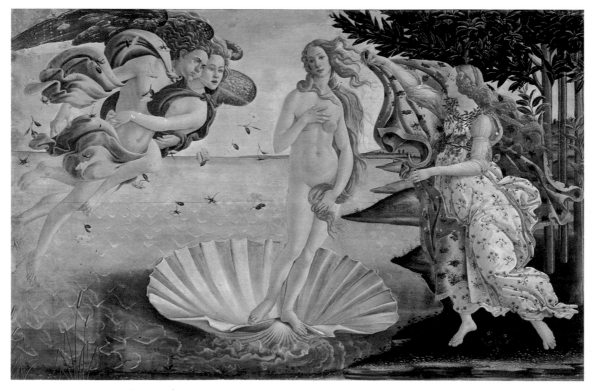

42. SANDRO BOTTICELLI. *The Birth of Venus.* About 1480–85. Uffizi Gallery, Florence

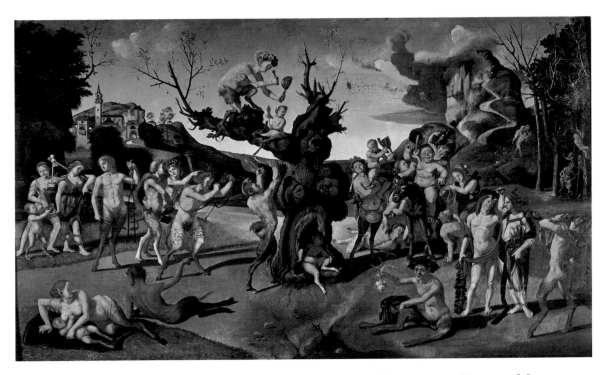

43. PIERO DI COSIMO. *The Discovery of Honey*. About 1498. Worcester Art Museum, Mass.

1500, is the very opposite of Botticelli's *Venus*: down-to-earth, gay, and colorful. Here we see Bacchus, the god of wine, and his goat-footed companions, the satyrs, participating in a sort of revel on a sunny summer afternoon. The god himself, looking slightly tipsy, stands on the right with his lady-love, Ariadne, but most of the satyrs pay little attention to him; instead, they busy themselves about the old willow tree in the center of the scene. If you look closely, you will find that they are all making as much noise as they can by banging their pots and pans, for they have discovered a swarm of bees, and the noise will make the bees settle in a cluster on one of the branches of the tree. The satyrs will then put them in a hive and, later on, collect their honey, from which they will make a kind of wine. Piero di Cosimo tells us all this in a high good humor, as if Bacchus and the satyrs were just plain, friendly country folk. And that, in a way, is what he really believed. The stories about the ancient gods, he thought, were actually about people who had lived in the early days of mankind, before history began. The discovery of honey must have been very important to these simple people; it was, after all, a first step toward civilization. That is why they honored the memory of the first beekeepers by making gods out of them. Thus Bacchus and his companions in our picture stand for "man's slow progress through the ages"—a less poetic idea than Botticelli's dream of "mankind reborn," but a far more realistic one. Piero's style, too, is more realistic. Like Ghirlandaio, he was interested in Flemish painting; the fine airy landscape background of his picture shows this Northern influence particularly well. But the landscape is not merely pleasant to look at, it also helps to drive home the "lesson" of the story. The rough, barren hill on the right stands for the primitive early days of man's life on earth, while the one on the left, with its little town and steeple, tells us of the blessings of civilized living. Thus the entire panel reflects the hopeful outlook of the Early Renaissance.

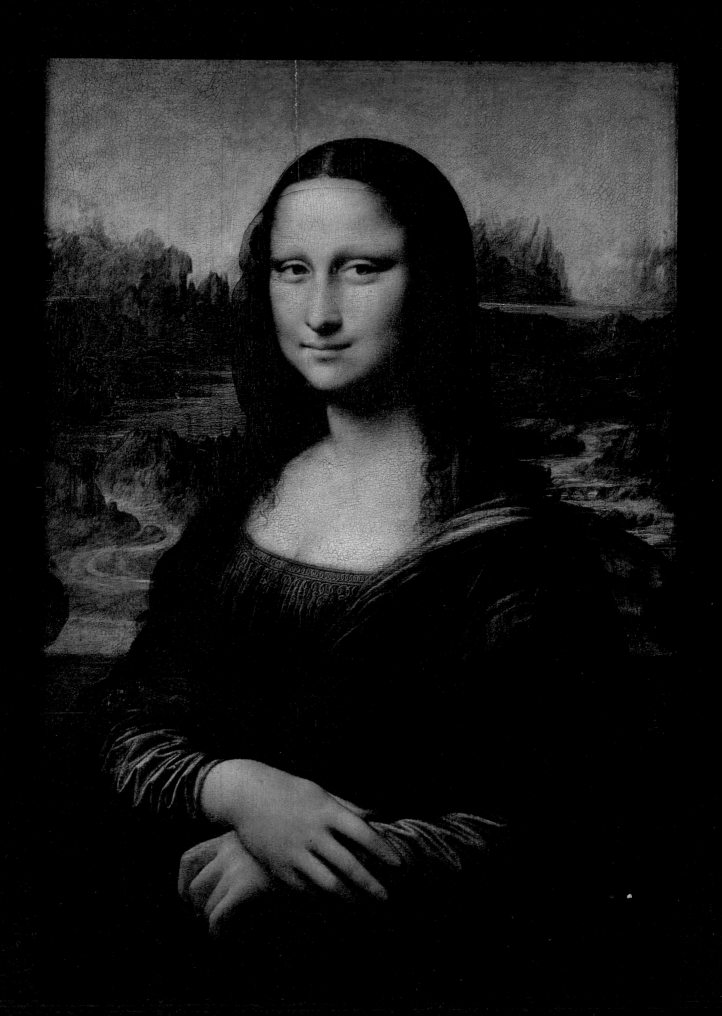

44. Leonardo da Vinci. *Mona Lisa*. About 1505. Louvre Museum, Paris

4

The Age
of Genius

As we enter the sixteenth century, we almost come to feel that the idea of "rebirth" was more than an idle dream. There are so many great men that they seem like a new race of giants, gifted with creative powers such as the human mind had never known before. At first glance, this Age of Genius may strike us as a much happier era than our own troubled times. In actual fact, however, it would be hard to find a century more unstable, more difficult to live in, than the sixteenth. It was a time of never-ending conflicts, both of arms and of ideas, for the discoveries of the previous hundred years had by now thoroughly upset the old order of things everywhere. The wealth in America and in other new-found lands across the seas started a scramble for power among the nations of Western Europe, with colonies and overseas trade as the stakes. These wars, in turn, were all mixed up with the great religious crisis, which disturbed people more than anything else that happened during those trying days. Christianity was divided against itself and, for the first time, the Catholic Church met with opposition; great reformers such as Martin Luther and John Calvin declared themselves independent of the authority of the Pope, and established Protestant Churches of their own in the countries north of the Alps. They found so many followers that the need was evident for this reformation of faith, since the Catholic Church at that time was still bound by medieval ideas; but the struggle between the two opposing camps was so cruel and bloody that it made quite a few people lose their trust in religion altogether.

How, you may wonder, could great masterpieces of art be created in the midst of all this turmoil? It is indeed difficult to say why we find many men of genius in some periods, and few or none in others. Still, let us keep in mind that the sixteenth century was also an age of challenge, when old barriers were breaking down and vast new horizons were opening up everywhere. Perhaps this unsettled state of affairs gave men a better chance to stretch their minds, and to accomplish great things, than they could have found in a stable and orderly world.

THE HIGH RENAISSANCE IN FLORENCE AND ROME

Among the artists of this time, three are so famous that their names have become household words: Leonardo da Vinci, Michelangelo, and Raphael. They lived during the High Renaissance in Italy, a glorious period at the beginning of the sixteenth century that was like the Classical Age of Ancient Greece. Leonardo da Vinci came closer to being an all-around genius than any other man in history, even though he proudly thought of himself first and foremost as an artist. But if we look into his notebooks and drawings, we find that his idea of art takes in a lot of things that today we call natural science. He believed so strongly in the eye as the perfect instrument for exploring the natural world that to him, seeing and knowing meant the same thing. Artists, he said, are the best scientists; not only do they observe things better than other people—they think about what they see, and then tell the rest of us about it in pic-

45. LEONARDO DA VINCI. *Sketches for the Battle of Anghiari.* About 1504.
Windsor Castle (Reproduced by Gracious Permission of H. M. the Queen)

tures. Nowadays scientists prefer to put their knowledge into words (they have had to invent a whole lot of new ones for this purpose), but in the Renaissance a good picture was still "worth a thousand words."

Leonardo's own drawings are so clear and full of life that even if we find it very difficult to decipher his notes (his handwriting was backwards), we can grasp his ideas by just looking at the drawings he made to illustrate them. No matter what we may be particularly interested in, we are apt to find that Leonardo was interested in it, too. He was the first man to seriously investigate aerodynamics and to design flying machines; he also drew meticulous and wonderfully exact pictures of the interior anatomy of the human body. These were but a few facets of his scientific inquiries, and in all these fields, Leonardo was far ahead of his time. His scientific mind can also be seen at work in one of the many preparatory studies he drew for a big battle picture about 1504 (plate 45). The point of the drawing is to show that animals and men have the same sort of expression on their faces when they are moved by the same strong feeling. In this case it is rage, and the man, the lion, and the horses are all baring their teeth and snarling. Here we really have one of the earliest studies in psychology, the science of the mind, which we like to think is something very modern.

Leonardo never actually finished the battle scene, but during those same years he did his most famous painting, the *Mona Lisa* (plate 44). If you compare it with earlier Florentine portraits (plates 40 and 41), you will see right away that Leonardo's seems more complete, more rounded. The figure, the low wall behind her, and the distant landscape are no longer set off from one another as separate things; the picture as a

65

whole has become more important than any of its parts. This new harmony was one of the aims of the High Renaissance. Leonardo has achieved it here not only by composing the picture more carefully but by painting everything as if it were seen through a slight haze that swallows up the small details, softens the outlines, and blends the shapes and colors together. In this way he leaves a good deal to our imagination, and that is why the *Mona Lisa* strikes us as so wonderfully alive. This is true both of the landscape (where Leonardo suggests to us how the earth "grew" from rocks and water) and of the face, with its mysterious smile. What is the *Mona Lisa* thinking about? That really depends on what we are thinking about as we look at her. Perhaps Leonardo himself was something like that; people always found him even-tempered and friendly, but nobody ever knew what was on his mind.

Michelangelo was in many ways the exact opposite of Leonardo. We know, in fact, that the two did not get on together at all. Michelangelo, too, had many different strings to his bow—he was a sculptor, architect, and poet, as well as a painter—but he took no interest in science. Leonardo could compare a man's face with that of a lion or a horse because human beings to him were simply part of nature as a whole. For Michelangelo, on the contrary, man was a unique and almost godlike thing; and the artist was not a calmly observing scientist but a creator whose hands could make dead materials suddenly come to life. To do this the artist needed more than a brilliant mind—he had to be inspired, and inspiration could come only from God, since the artist was, in a way, competing with Him. Michelangelo himself never decided whether to see his gift as a blessing or a curse. His violent personality, always torn between hope and despair, filled those who knew him with such awe that they really felt there was something superhuman about him. He has done more than any other man to shape our idea of what genius is like, so that even now we still tend to think of it as a strange power that holds the artist in its grip.

Michelangelo's masterpiece is the huge fresco covering the entire ceiling of the Sistine Chapel in the Vatican. He did it between 1508 and 1512 for Julius II, the great Pope during whose reign Rome became the center of Italian art. Plate 46 shows one of the main scenes, *The Creation of Adam*. It will remind you of the monumental style of Giotto and Masaccio, but there is a forcefulness of action and feeling here that we have never seen before. These mighty creatures, stronger and more perfectly formed than any man could hope to be, come to us not from the *real* world of nature but from the *ideal* world of Michelangelo's imagination. The figure of God rushing through the sky is nothing less than creative energy itself. Adam, in contrast, still clings to the earth from which he has been molded. Their hands reach out to each other across space, and we can almost feel the breath of life flowing into Adam. No other artist has ever equaled Michelangelo's vision of this fateful moment. Around the main scenes on the ceiling there is a framework painted to look like stone, with seated figures in niches. One of these, the Prophet Jeremiah, is shown in plate 47. His body gives an even greater feeling of bulk and strength than those in *The Creation of Adam*, yet it is apparent that all his energy is turned inward upon the dark thoughts that

46. MICHELANGELO. *The Creation of Adam.* Fresco, Sistine Ceiling. 1508–12. Vatican, Rome

47. MICHELANGELO. *The Prophet Jeremiah.* Fresco,
Sistine Ceiling. 1508–12. Vatican, Rome

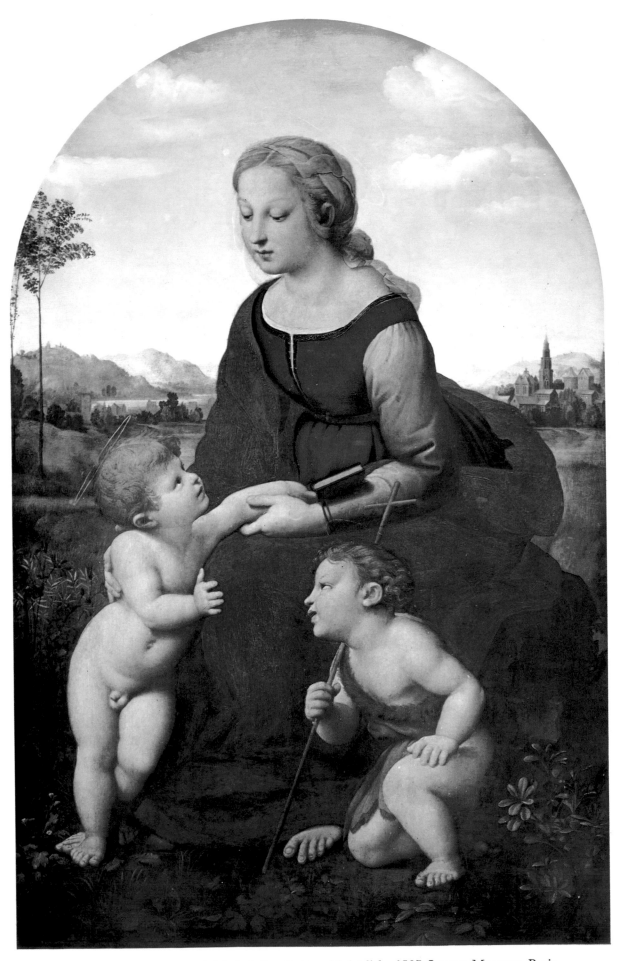

48. RAPHAEL. *Madonna with the Infant Christ and Saint John.* 1507. Louvre Museum, Paris

The Age of Genius

fill his mind. This quality is made even more immediate when we realize that Michelangelo has portrayed something of his own character in this gloomy figure.

How different are the paintings of Raphael! Younger than Leonardo and Michelangelo, he was the happiest and least complicated of the three. He, too, came to Rome at the request of Pope Julius II, but he had already seen Leonardo's work in Florence and learned a great deal from it. In the lovely *Madonna* panel of 1507 (plate 48), the softness of the modeling, the calm beauty of the Virgin, and the way her left arm is placed, show the influence of the *Mona Lisa*. Yet Raphael's works embody none of those disquieting mysteries that make Leonardo so difficult to understand.

In Rome, Michelangelo's Sistine Ceiling made a deep impression on Raphael. This new influence may be seen in *The Expulsion of Heliodorus* (plate 49), one of the

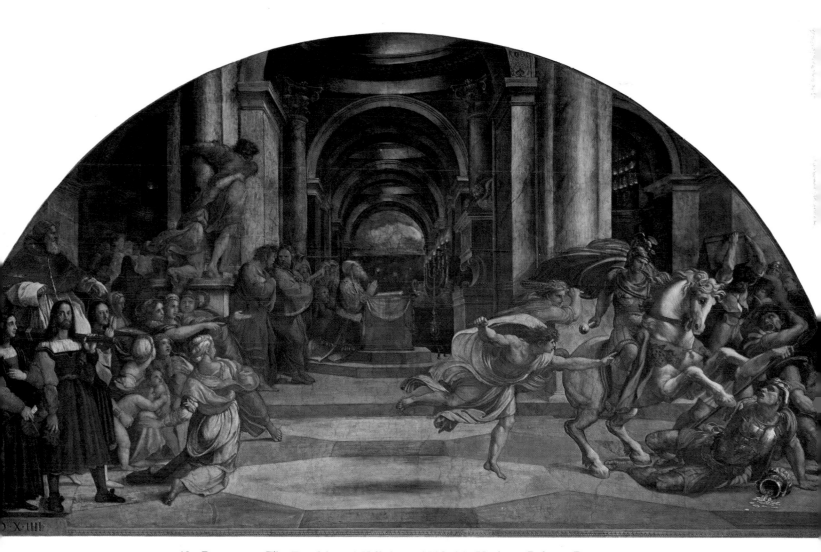

49. RAPHAEL. *The Expulsion of Heliodorus.* 1512–14. Vatican Palace, Rome

frescoes he painted in the Vatican Palace between 1512 and 1514. It illustrates the story of a pagan Greek soldier who had brashly entered the Temple in Jerusalem in order to carry off its treasures. In the back of the picture, the High Priest at the altar is asking the Lord's help, and his prayer brings the three armed messengers of God, on the right, who chase away Heliodorus and his men. These figures are as powerfully built as those on the Sistine Ceiling, and even more agitated; the horse has all the supercharged energy found in the study by Leonardo in plate 45. The drama has been turned into action, so there is no "battle of feelings" within Raphael's figures, such as we found in Michelangelo's style. What we admire most about *The Expulsion of Heliodorus*, however, is its masterly composition. Only a genius could have made a stable, well-balanced whole out of so many figures doing different things. The way they are fitted into the architectural framework, which forms the backbone of the entire picture, reminds us of Masaccio's *Trinity* mural (plate 34), except that Raphael's design is far richer and full of movement.

THE HIGH RENAISSANCE IN VENICE

After the death of Julius II in 1513, Rome did not long remain the great center of art it had been. Meanwhile, a new school of painting had grown up in the rich seafaring and trading city of Venice, in the northeast corner of Italy. The first master of the Venetian High Renaissance was Giorgione, who died in 1510 when he was still in his early thirties. We know only about half a dozen pictures that can be securely attributed to him, yet he is ranked among the greatest painters in history, for it was he who brought to Venetian painting most of the special qualities that set it apart from all the other styles of the sixteenth century. In his splendid *Concert* (plate 50), we find it hard to tell what kind of story the artist had in mind. The more we look at the figures, the less certain we become about what exactly they are doing. All we can say is that they seem happy in each other's company. Perhaps the difference between the two young men gives us a clue to the riddle: one is a barefoot boy, very simply dressed, while the lute-player sports an elegant and colorful costume. Could Giorgione have wanted to contrast country life and city life in these figures? As for the two women, we know only that they must have a Classical meaning of some sort; they are probably nymphs or similar woodland spirits in human shape as imagined by the Ancients.

Oddly enough, not knowing the story seems to make little difference to us. The charm of the picture, we feel, is in its mood rather than its action, as if the artist had made up a poem—calm and gentle, yet a little sad, too—and then painted it instead of writing it down. Now, Giorgione was not the first painter to be interested in mood, but with him it became more important than anything else. Michelangelo and Raphael had created an ideal world through their mastery of form; Giorgione created *his* ideal world—a warmer and more human one than theirs—out of light and color. Instead of making us stand in awe, he invites us inside to share it with him. In the

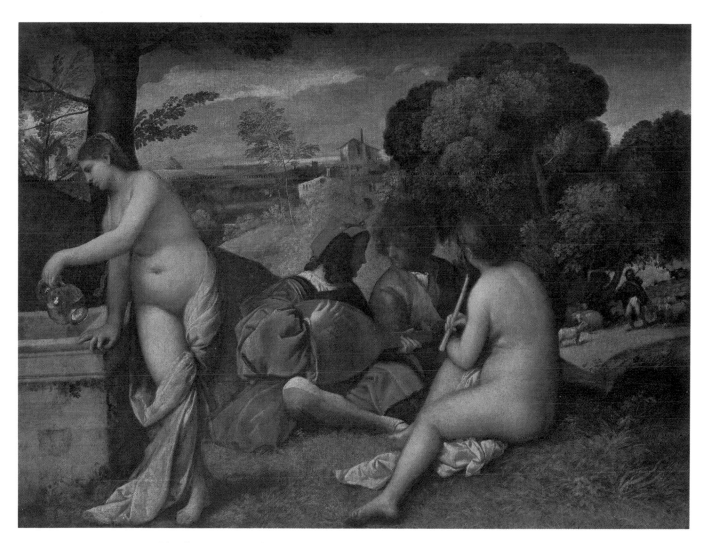

50. GIORGIONE. *The Concert.* About 1510. Louvre Museum, Paris

Concert, the golden rays of a setting sun bring all the details into harmony. If we could only make this wonderful moment last forever! But the shadows are deepening, and night will be here soon.

Giorgione's new way of painting was explored further by Titian, who outlived him by a great many years and who was to become the most brilliant and famous of all Venetian artists. Titian, however, also knew something of the work of Michelangelo and Raphael. In the *Bacchanal* (plate 51), which he painted about 1518, the landscape, rich in contrasts of cool and warm tones, has all the poetry of Giorgione, but the figures are of another breed: active and muscular, they move with a new, joyous freedom. Inspired by an ancient writer's description of a pagan revel, Titian has painted the realm of myths as inhabited by beings of real flesh and blood who invite us to share their blissful state. They are idealized just enough beyond everyday reality to persuade us that they belong to a long-lost golden age.

The Age of Genius

Titian's greatest fame was as a painter of portraits. All the important men of his day, from the Pope and Emperor on down, were eager to have their pictures done by him. You will understand why if you look at the *Man in a Red Cap* (plate 52), which shows all his mastery of light and color. With quick, feathery strokes of the brush, Titian captures the "feel" of the materials so completely that they seem richer and more precious to us than they would be in real life. And the unknown sitter, too, we suspect, looks more attractive than he actually was—not more beautiful, perhaps, but more interesting, more sensitive. Lost in his own thoughts, the young man seems quite unaware of us. It is this slight touch of sadness that gives him such unusual appeal.

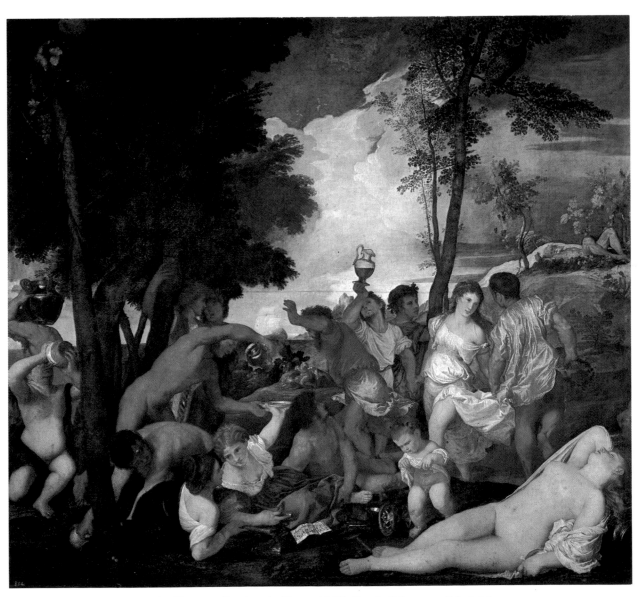

51. TITIAN. *Bacchanal*. About 1518. Prado Museum, Madrid

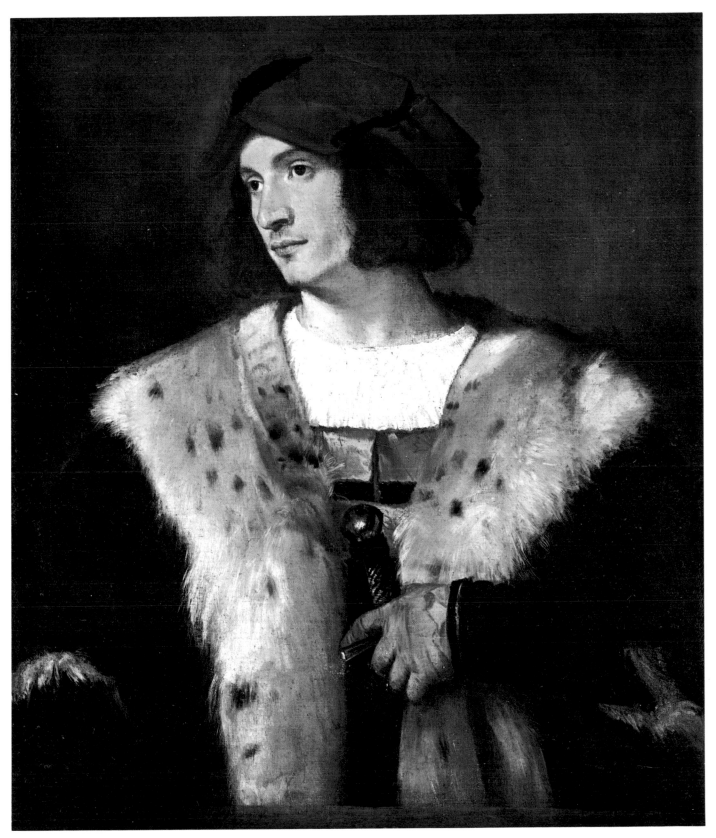

52. TITIAN. *Man in a Red Cap*. About 1530. The Frick Collection, New York

The Age of Genius

MANNERISM AND OTHER TENDENCIES

In Italy, the home of the Catholic Church, the Reformation did not touch the artists directly. Yet there, too, the great crisis of faith had a deeply unsettling effect upon their work. After 1520, the confidence of the High Renaissance in the almost divine powers of the human spirit was no longer shared by the younger artists; to them, man seemed once again at the mercy of forces over which he had no control. So they began to show the human figure in strange new ways, twisting it into ever more impossible poses and pulling it out to unnatural height. Some of them even developed a strong taste for the Late Gothic. This disturbing phase of Italian art used to be looked down upon as the "decay of the Renaissance"; that is what the label "Mannerism" meant. But we now accept it as an important style in its own right, and the highly personal flavor of the best of the Mannerists seems particularly exciting to modern eyes—perhaps because we, too, no longer believe in fixed ideals in art. The early Mannerists working in Florence depended far less on nature and on Ancient art than on their private worlds of dreams and visions. You can see the beginning of the new style in the superbly dramatic *Descent from the Cross* in plate 53, which was done in 1521 by a painter known simply as Rosso ("Red"; or, sometimes, Rosso Fiorentino). The spidery, angular figures, their frenzied gestures and expressions, the weird, unreal light—all these give the picture a ghostly, frightening quality that is not soon forgotten. Rosso's men and women are no longer acting, they are being acted upon; their garments and their very bodies have turned brittle, as though frozen by a sudden blast of cold. Nothing would seem to be more remote from the Classical balance of the High Renaissance than this nightmarish style. Yet, if we look closely, we can see that the picture has a careful balance of a different kind and that the solid figures recall those in Raphael's *Expulsion of Heliodorus* (plate 49). We realize, then, that Rosso is not entirely "anti-Classical," and that no matter how different it seems, his work is based on the High Renaissance.

This early phase of Mannerism was soon replaced by a less extreme one. The extraordinary *Self-Portrait* (plate 54) by a young painter from Parma called Parmigianino was done in 1524, only three years after Rosso's *Descent*. It shows the artist exactly as he saw himself in one of those round, convex, distorting mirrors, so that his hand looks monstrously large and the walls and ceiling of the room are bent into curves. Why was Parmigianino so fascinated by these distorted shapes? Was it merely scientific curiosity, or had he come to feel that there was no such thing as a steady, "correct" reality, that everything depended on your personal point of view?

In Venice, Mannerism did not appear so quickly, but by the middle of the century we find it firmly established in the work of Tintoretto, acknowledged as the most important Venetian master after Titian, from whom he certainly absorbed many lessons. His *Presentation of the Virgin* (plate 55) is less "anti-Classical" than Rosso's *Descent*; the vigorous poses of some of the figures may remind you of Michelangelo, whom Tintoretto admired greatly. Even so, you can feel the Mannerist spirit in the

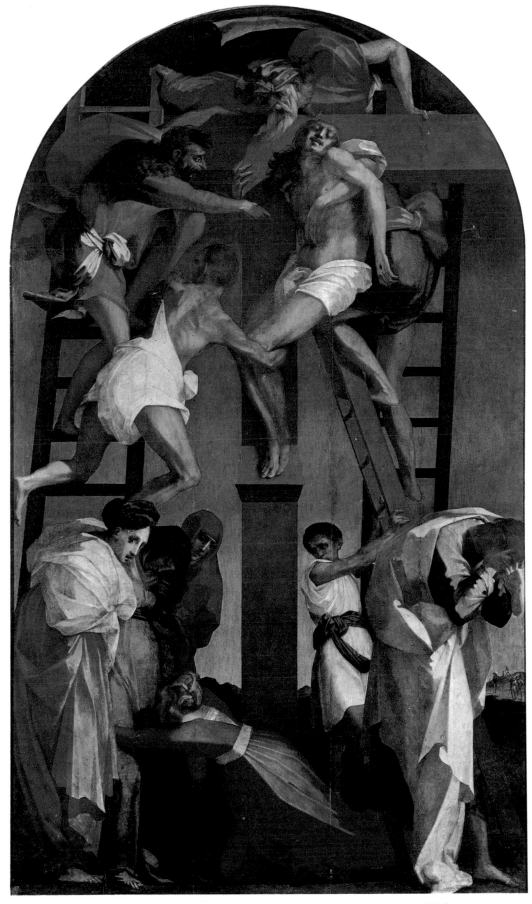

53. Rosso Fiorentino. *Descent from the Cross*. 1521. Pinacoteca, Volterra

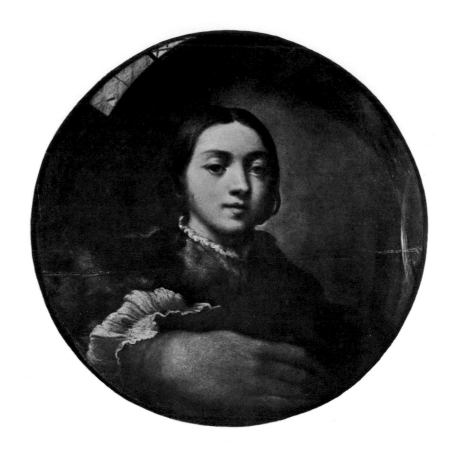

54. PARMIGIANINO. *Self-Portrait*. 1524.
Kunsthistorisches Museum, Vienna

odd perspective, in the strange, unsteady light with its sudden bright flashes and deep, inky shadows, and in the over-dramatic gestures of the figures as they watch the twelve-year-old Mary going up the steps to the Temple. What matters most to Tintoretto is not the simple, straightforward story from the life of the Virgin but the tense, excited air he has given to the scene, as if we were witnessing some tremendous drama.

This style of painting fitted in well with a new trend in the Catholic world. In defense against the Reformation, the Church had begun to stress the mystical and supernatural parts of religious experience. This "Counter-Reformation" was strongest in Spain, and it is in Spain that we find the last and most striking of the Mannerist painters. He is known today simply as El Greco, "The Greek," since he was born on the island of Crete. His style of painting, however, was formed under the influence of Tintoretto and other masters in Venice, the city which ruled Crete at that time. He went to Spain as a mature artist and settled in the town of Toledo. El Greco's first great success there was the *Assumption* (plate 56) of 1577. It shows the Virgin Mary being carried to Heaven after her death, in the presence of the Apostles. The sudden flashes of light and the curiously unreal colors will remind you of Tintoretto, but in spirit the work seems closer to Rosso's *Descent*, for here again we find the sharp-edged, "frozen" draperies, the angular, frantic gestures, the drawn-out limbs. And El Greco handles space in an even more personal way than Rosso does; he uses fore-

The Age of Genius

shortening, but without perspective, so that we cannot tell from what level we are viewing the scene. Then, too, there is a good deal of modeling in all the figures, and yet they look like cardboard cutouts placed one over the other, with no space between them. Thus El Greco makes it quite impossible for us to separate the real from the unreal, the world of feeling from the world we can see and touch.

In sixteenth-century Italy, Mannerism was certainly the most interesting movement, but it was by no means the only one. This was a time full of inner contradictions, much as our own era is, and these gave rise to many competing styles. In Venice

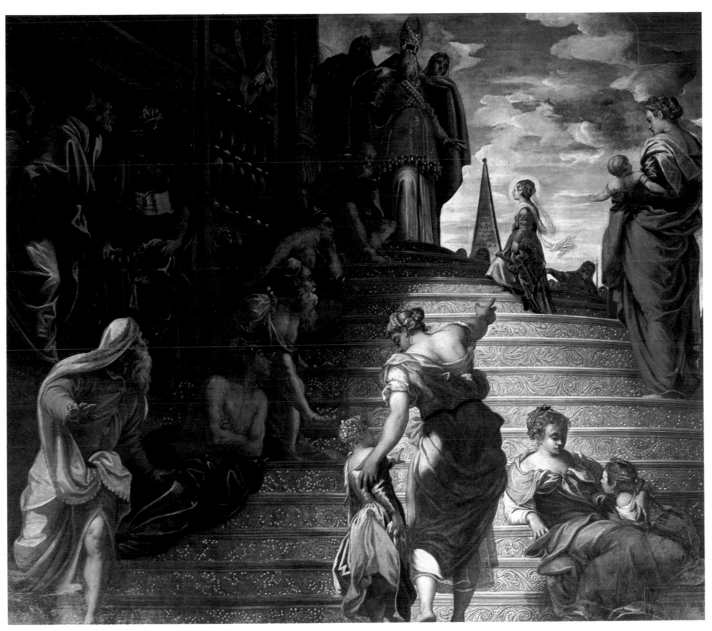

55. TINTORETTO. *Presentation of the Virgin*. About 1550. Church of Santa Maria dell'Orto, Venice

56. EL GRECO. *Assumption of the Virgin*. 1577. The Art Institute of Chicago

there was another artist, this time from Verona and named Paolo Veronese, whose fame was second only to Tintoretto's, though his work is very different.

The new broad manner of using oil paint introduced by Giorgione and Titian no longer demanded the smooth surface of wooden panels. The Venetian masters preferred to do their pictures on heavy canvas cloth. This was found to be so much cheaper and more convenient that painters have been using canvas ever since. It also allowed the Venetians to make oil paintings as large as wall paintings. *Christ in the House of Levi* (plate 57), done in 1573 by Paolo Veronese, is a splendid example of such a wall decoration. It is much more "Classical" in its balance than Tintoretto's *Presentation* but it shares much the same excitement. The sparkling, colorful costumes and the splendid architecture make us think of an exuberant party in the palace of some Venetian lord, rather than of a story from the Bible. But if the picture does not strike a very religious mood, Veronese gives us a wonderfully rich and vivid account of the festive scene, as if he had staged this pageant of Venetian life for our special benefit. Veronese's appeal to the senses was part of a general trend in Northern Italy toward a new kind of naturalism which anticipates Baroque art.

Another artist who looks forward to the seventeenth century is Correggio, born in a small town near Parma. In his *Holy Night* (plate 58), done about 1530, the bold lighting looks very Venetian, while the figures show that he must have known something of Leonardo, Michelangelo, and Raphael. And yet the picture as a whole is quite unlike any of theirs. First of all, the figures don't stay put inside the frame but

57. Paolo Veronese. *Christ in the House of Levi.* 1573. Academy, Venice

58. CORREGGIO. *The Holy Night*. About 1530. Picture Gallery, Dresden

keep bursting into the picture from outside: look at the huge shepherd on the left, and the whirling cloud of angels above him. Obviously, Correggio is much less interested in balanced design than he is in making us feel the excitement of the story. He shows us the birth of Christ as a great miracle, but one that looks real and natural, too. That is why he has made it a night scene lit up by the new-born Child, just as Gentile da Fabriano had done (compare plate 27). In his own day Correggio was not regarded very highly. But a century later many other painters took over his sensational style, and he suddenly became as famous as the great masters of Rome and Venice.

The Age of Genius

THE NORTHERN RENAISSANCE

Around 1500 the painters in Northern Europe showed a growing interest in Italian art. The Late Gothic style, however, was still very much alive, and there followed a long tug-of-war between the two until the Italian influence finally won out. We can get a good idea of this "battle of styles" by comparing the two greatest Northern painters of that time, Matthias Grünewald and Albrecht Dürer. Both of these men were Germans and their backgrounds had much in common; and yet their aims were as different as could be. Grünewald's masterpiece, *The Isenheim Altar*, was done at just about the same time that Michelangelo finished the Sistine Ceiling. Its four huge wooden wings are painted on both sides (plate 59 shows you the altar with the outer panels opened up). Grünewald had already felt the influence of Renaissance art: he knew more about perspective than he could have learned from the Late Gothic alone, and some of his figures, too, are surprisingly solid and vigorous. But his imagination is still completely Late Gothic, and he uses Italian ideas only in order to make this world of dreams and visions more real, more exciting than ever before. *The Isenheim Altar* is the final outburst of this particular kind of creative energy—an energy so intense that everything in these panels twists and turns as though it had a life of its own. Let us compare the *Annunciation* on the left-hand wing, for instance, with the earlier panel by Roger van der Weyden (plate 30). Roger's Christ enters so quietly that He hardly seems to move at all, while Grünewald's angel is blown into the room by a tremendous gust of air that makes the Virgin reel backward. On the two center panels a fairy-tale orchestra of angels entertains the Madonna and the new-born Child. There is a great burst of light above the clouds from which God the Father, in all His glory, gazes upon the young mother and her babe. In this tender and poetic vision, Heaven and earth have truly become one in celebrating the miracle of Christ's birth. Among all the pictures we have seen so far, only Correggio's *Holy Night* arouses similar feelings, different as it is in every other way.

The *Resurrection*, on the right, is the most dramatic panel of *The Isenheim Altar*. Here an even more awesome miracle happens before our eyes: Christ leaves the earth and becomes God once more. But He does not merely *rise* from the grave—He *explodes* upward in a spiraling rush, still trailing His shroud and shining with a light as brilliant as the sun against the midnight sky, while the guardians of the tomb, the forces of death, blindly grope along the ground in utter defeat. Here the strange genius of Grünewald has created its most unforgettable image.

Little is known about Grünewald's life. In the case of Dürer, on the other hand, we can trace his development almost year by year. Plate 60 shows you a drawing he made of himself in 1484, when he was only thirteen and had just started his training under a painter in his home town of Nuremberg. Even then, Dürer could draw with great delicacy and assurance, but the style of the portrait is still entirely Late Gothic. Its sensitive, yet curiously timid look will remind you of the *Young Princess* by the Master of Moulins (plate 32). If we now turn to Dürer's painted self-portrait (plate 61),

59. MATTHIAS GRÜNEWALD. *Annunciation, Madonna with Angels, Resurrec*

done in the year 1500, we can't help wondering whether this impressive, almost Christ-like figure is really the same person as the unsure boy in the early drawing. During those sixteen years, everything about Dürer had changed: his style, his ideas, and his way of looking at himself. Pictorially it belongs to the same Flemish tradition as Jan van Eyck's *Man in the Red Turban* (plate 29). But on his first visit to Italy, Dürer discovered both a new kind of art and a new kind of artist. He had been brought up to think of painters as modest craftsmen; in the South, he found, painters were learned men who enjoyed the same respect as scientists, scholars, and philosophers. So he

panels of the *Isenheim Altar.* 1511–12. Unterlinden Museum, Colmar

decided not only to make the Italian style his own, but to educate himself in all the fields of learning that went with this new approach to art. More than that, he felt called upon to spread his own knowledge among his fellow artists, like a missionary preaching a new faith. Dürer even wrote about scientific perspective. (This was another idea he got from Italy—you will recall that Piero della Francesca had written a similar book.) In the self-portrait of 1500 he sees himself in this important new role; it is an idealized picture of the artist, much as the *Mona Lisa* is an idealized portrait of a woman (plate 44).

60. ALBRECHT DÜRER. *Self-Portrait.*
Drawing. 1484. Albertina, Vienna

61. ALBRECHT DÜRER. *Self-Portrait.*
1500. Pinakothek, Munich

Dürer's "mission" was helped a great deal by the fact that he was the finest print-maker of his time. These prints were of two kinds: engravings, where the lines of the picture are cut into a sheet of copper with a steel point; and woodcuts, where the spaces between the lines are carved out of the surface of a wooden block, leaving a raised design. Both copper plates and woodblocks can then be inked and many copies can be printed. Such prints, needless to say, are much cheaper than paintings, so that a great many more people can afford to buy them. Dürer's engraving of *Adam and Eve* in plate 62 shows how much he had learned from artists in Venice such as Andrea Mantegna. The figure of Adam reminds us of Christ in the Italian painter's *Crucifixion* (plate 39). But Dürer did not imitate Italian art slavishly. He picked what he thought was interesting and impressive and then combined it with his own ideas, in the spirit of his own time and place. All we have to do is look at his Eve next to Botticelli's more graceful *Venus* (plate 42) to realize how different he was from the Italians.

In Dürer's splendid engraving of 1513, *Knight, Death, and Devil* (plate 63), the horse and rider have the calmness, the solid and monumental form of similar Italian works, such as the mounted soldiers of Piero della Francesca (plate 36), while Death and the Devil show the same weird imagination that we know from the Van Eyck *Last Judgment* (plate 28). The contrast between the two styles helps to make Dürer's idea clear: his Knight is the exact opposite of those futile pleasure-seekers in Jerome Bosch's *Ship of Fools* (plate 33). He "knows where he is going"; his journey through life fol-

62. ALBRECHT DÜRER. *Adam and Eve.*
Engraving. 1504. Museum of Fine Arts, Boston

63. ALBRECHT DÜRER. *Knight, Death, and Devil.*
Engraving. 1513. Kupferstichkabinett, Berlin

lows the road to Heaven (represented by the city in the distance) no matter how frightful the dangers along the way. The famous hymn "Onward, Christian Soldiers" might well provide the title for Dürer's picture.

Hans Holbein the Younger was the last of the great German masters of this period. His best-known works are the portraits he did in England, where he spent the later years of his life as court painter to King Henry VIII. The portrait of George Gisze (plate 64), painted in 1532, strikes a happy balance between the Northern European love of fine surface detail and the solidity and dignity of Italian Renaissance art. While the sitter has not been idealized in any way, he reminds us of Titian's *Man in a Red Cap* (plate 52). His pose, too, has something of the restful, harmonious quality of the *Mona Lisa*; and compared to Late Gothic portraits, this young merchant seems to have a new confidence in himself and in his own worth. Perhaps this was the reason he commissioned the artist to portray him. Holbein shows him in his office, surrounded by business papers, seals, writing equipment, even a vase of flowers. These things only add to the feeling of quiet pride conveyed by the picture as a whole.

At the time Holbein came to England, the religious Reformation movement was already widespread in Northern Europe. Artists felt its effect more directly, perhaps, than anyone else, for all the new forms of faith agreed on one point: religious art, they claimed, tempted people to worship statues and pictures rather than God Himself. Wherever the Reformers won, their Church no longer demanded—and in some countries even prohibited—these sacred subjects that had been the mainstay of

64. HANS HOLBEIN THE YOUNGER. *George Gisze*. 1532. State Museums, Berlin

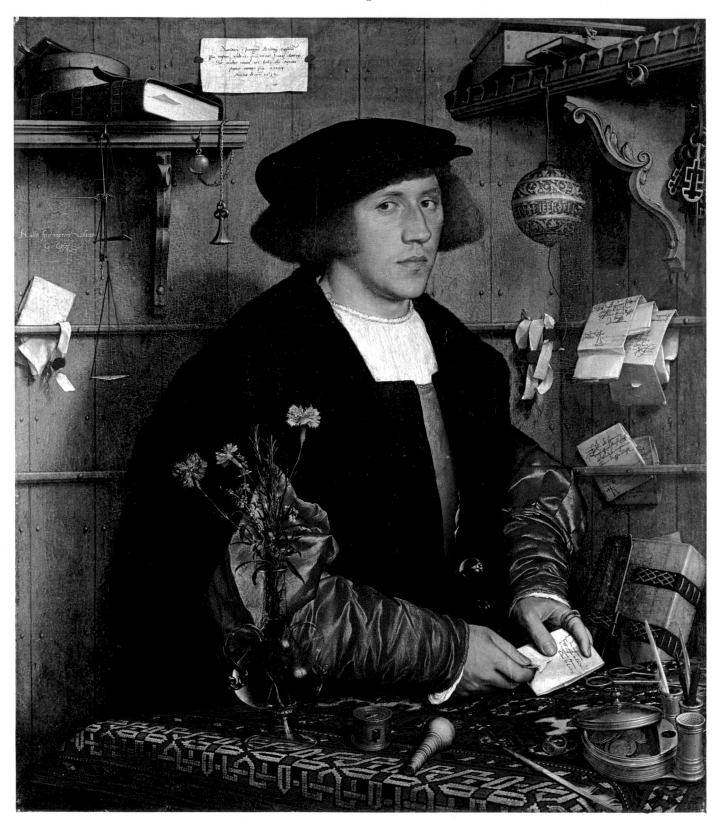

65. PIETER BRUEGEL. *The Land of Cockayne*. 1567. Pinakothek, Munich

medieval art. As a result, religious pictures became much less important than before, and painters had to turn to other subjects in order to make a living. Holbein, as we have seen, concentrated on portraits. In plate 65 we meet a different kind of new subject. The picture was painted in 1567 by the great Flemish master Pieter Bruegel, at a time when the Netherlands, under the banner of the Reformation, was fighting a bloody war of independence against Catholic Spain. It shows the *Land of Cockayne*, a kind of fool's paradise where tables are always laden with tasty dishes, houses with roofs made of pies, and other wonders. Bruegel, of course, wants to teach us a moral lesson, but he no longer needs religion for this. The men under the tree are not unhappy sinners in the grip of evil, like the voyagers in Bosch's *Ship of Fools* (plate 33); these *could* act as responsible human beings but, like most people, they are not wise enough to know what is best for them in the long run. By becoming slaves to their appetites, they have given up all ambition, all self-respect, for the sake of some form of animal happiness: the knight has dropped his lance, the farmer his flail, and the scholar, lying on his back, has let fall his book and paper. "Beware of the fool's paradise," Bruegel seems to say, "it's more dangerous than Hell because people *like* going there."

87

It is not easy to define the spirit of seventeenth-century art. We often speak of it as the Baroque, but nobody seems to be quite sure what this means, or ought to mean. The word itself might be compared to the term Gothic, which at one time merely indicated that the art of the late Middle Ages was clumsy and of poor quality, although it has become thoroughly respectable since then. Baroque, too, started out as an insulting tag for certain kinds of seventeenth-century art, but because the term did not come into general use until recent times, its negative meaning has not yet worn off completely (there are still many who consider Baroque as a synonym for "excessive"). Quite a few people still feel that it is all right to call *some* seventeenth-century artists Baroque but not others. In this book we shall be less cautious; we shall use Baroque for the last phase of the Renaissance era (after Early Renaissance, High Renaissance, and Mannerism), just as Gothic means the last phase of the Middle Ages. If you think of it like that you will understand more easily how seventeenth-century art could be as rich and varied as it was and yet have a decided character of its own.

In many ways the Baroque Age sums up all the different trends we have seen since the early fifteenth century. People were no longer so upset by the exciting new ideas and discoveries that had brought the medieval world to an end; they had learned how to live with them and what to do with them. Earlier, we had found daring explorers like Columbus setting out to bring back the riches of unknown lands. These were now followed by colonists, such as the Pilgrim Fathers who settled in New England in 1620. The countries along the Atlantic coast of Europe—England, Holland, France, Portugal, and Spain—had all gained important overseas territories and grown more prosperous and powerful than they had been before, while Germany and Italy became less so. In art and science we no longer find all-around geniuses like Leonardo and Dürer, who opened up new fields of knowledge all at once. They had taught the specialists how to use their eyes, but it remained for the latter to describe the workings of nature in an orderly and systematic manner. So now there were scientists such as Galileo and Newton, who summed up the behavior of moving bodies in a few simple laws that held good for every kind of motion, whether it was the earth circling around the sun or an apple dropping from a tree. These important scientists of the Baroque Age laid the foundation for the technical marvels of our own day.

THE BAROQUE IN ROME

The struggle between the Reformation movement and the defenders of the old faith had reached a stalemate, with the ideologies of both factions attaining a type of stability, so that there was less open conflict than before. The Catholic Church, its strength revived by the Counter-Reformation, could feel secure once more, and the city of Rome again became the goal of artists from all over Europe. They came, of

course, to study the great masterpieces of Classical Antiquity and of the High Renaissance; but they also learned from the Italian artists of their own time, and these, in turn, picked up ideas from them. In fact, seventeenth-century Rome was a sort of melting pot of styles, where North and South, past and present, flowed together in an endless and bewildering stream. Every visitor came away from it with a different impression, yet the experience gave all of them something in common—enough, at any rate, to make us feel that the Baroque was an international style, however much it might vary from one place to the next.

The foreign artists who arrived in Rome toward the year 1600 found the Italians all excited about a young painter named Caravaggio who had himself been in the city only a few years, coming from a town in Northern Italy. Two things about him impressed them particularly: Caravaggio's new sense of timing, which let him catch his characters at exactly the right moment, and his dramatic use of light and dark. He was the first painter to spotlight his pictures like a stage director, contrasting brilliant highlights with sharply outlined, deep shadows that make every face, every gesture as expressive as possible. A look at his *Calling of Saint Matthew* (plate 67) will make you realize how little his work has in common with the strained, other-worldly art of the Mannerists. Caravaggio had learned a good deal from the Venetian High Renaissance style (compare plates 50 and 51), but he refused to idealize his figures. His own outlook was naturalistic, which means that he wanted to show the world just as he saw it in everyday life. He painted this story from the life of Christ as if it were happening right then and there in a Roman tavern. Saint Matthew, with red sleeves, sits with the group on the left. The Saviour comes in on the right with one of His disciples. Both of them are obviously poor and humble people—barefoot, and wearing simple clothes that make a strong contrast with the colorful costumes of the others. As Christ raises His arm in a beckoning gesture, a golden beam of sunlight falls through the window behind Him and carries His call across to Matthew. It seems a perfectly natural kind of light, but the way it points at Matthew and lets Christ's hand and face suddenly emerge from the dark gives it a symbolic meaning, too. As a matter of fact, this beam is by far the most important thing in the picture. Take it away, and all the magic, all the expressive power, disappears with it. You will now understand how Caravaggio could translate this important Biblical story into the work-a-day reality of his own time and yet fill it with the deepest religious feeling; it is his discovery of light *as a force* that raises this tavern scene to the level of a sacred event.

Caravaggio's style was based in part on the art of Northern Italy, including Venice, which he combined with that of Rome. So was Giovanni Lanfranco's, only his sources were different. He flooded the restless composition of *The Annunciation* (plate 68) with a miraculous light and color. We have seen this kind of explosive excitement already, in the *Holy Night* (plate 58) painted by Correggio nearly a

The Triumph of Light

century before in Parma, where Lanfranco received his early training. This liveliness and immediacy was an important contribution to the Baroque and made Lanfranco one of the most popular artists in Rome. His religious paintings were actually preferred by many people to Caravaggio's, which they thought were "undignified."

Caravaggio's naturalism seemed less strange to visiting foreigners than it did to the Italians, because Northern artists had been familiar with the human, everyday approach to religious stories ever since Gothic times. While he was not exactly a prophet without honor in his own country, Caravaggio left a deeper impression on the Netherlands, France, and Spain. His ideas influenced all the important masters of Baroque painting, even those who became far more famous than he did.

67. CARAVAGGIO. *The Calling of Saint Matthew*. About 1597–98. Contarelli Chapel, Church of San Luigi dei Francesi, Rome

68. GIOVANNI LANFRANCO. *The Annunciation.*
About 1616. Church of San Carlo ai Catinari, Rome

RUBENS: THE BAROQUE IN FLANDERS

The first of these, Peter Paul Rubens, was from Flanders, the southern part of the
Netherlands that remained Catholic and under Spanish rule, while Holland, the north-
ern half, was struggling to maintain its independence. As a young man Rubens
spent eight years in Italy, eagerly studying the works of the great painters from the
High Renaissance to his own day. By the time he returned home to Antwerp, he had
learned much more about Italian art than any Northern artist before him. It might
well be said of him, in fact, that he finished what Dürer had started to do a hundred

69. PETER PAUL RUBENS. *Crucifixion*. Altarpiece.
1620. Royal Museum of Fine Arts, Antwerp

years earlier—to break down the barriers of taste and style between North and South. The wonderful *Crucifixion* of 1620 (plate 69) shows you how much Rubens owed to the Italians: here you find the powerful bodies of Michelangelo and Raphael, the sparkling color of Titian, the careful imbalance of Rosso, the dynamism of Lanfranco, the sweep of Correggio, and Caravaggio's naturalism, drama, and spotlighting, along with a force of expression that will remind you of Grünewald. The amazing thing about Rubens' genius is that he was able to digest all these different sources so skillfully that we don't even notice them, unless we make a special point of looking for them. If he borrows the "words" of other artists, he gives them a new sound and a new meaning, so that they become part of his own personal "language." And what an exciting, colorful language it is! For Rubens, nothing ever stands still; all his forms are alive with a flowing, swirling movement that sweeps through his pictures like a windstorm. A Rubens scene is never complete in itself—it spills over the edges of the canvas on every side, and the frame simply cuts across it (just compare his *Crucifixion* with the one by Mantegna in plate 39). The idea of composing pictures in this way came, of course, from Correggio, but Rubens carried it a great deal further. "After all," he seems to tell us, "in the real world there are no limits to space or time; life as we know it means change, movement, action. Why should things be different in the world of art?"

You can see all this even better in our next picture (plate 70), which is a small

94

70. PETER PAUL RUBENS. *Marie de' Medici, Queen of France, Landing in Marseilles.*
Oil sketch. About 1622. Pinakothek, Munich

The Triumph of Light

sketch for a very large painting, one of a series Rubens did in 1621–25 for the Queen of France. It shows her arrival in Marseilles (she was Italian and had come to France by boat). Not a very exciting story, you might say—but Rubens turns it into a glorious, swirling, exciting spectacle of a kind we have never seen before. As the Queen walks down the gangplank, the winged figure of Fame flying overhead sounds a blast on his trumpets, and Neptune, the mythological god of the sea, emerges from the deep with his fish-tailed crew; they have guarded the Queen's ship during her journey, and are overjoyed at her safe landing. In this festive scene everything flows together: heaven and earth, fantasy and reality, motion and emotion. Even drawing and painting have become the same thing in our sketch, for Rubens could not plan the design of the picture without thinking of light and color from the very start, just as in real life there is no form apart from light and color. It is this unified way of seeing that makes his work, and Baroque art in general, so different from all earlier styles.

HOLLAND AND THE PROTESTANT BAROQUE

While Rubens became the most famous artist of his time in the Catholic half of Europe, the first great painters of the Protestant world appeared in Holland. As a wealthy nation of merchants and seafarers, proud of their hard-won freedom, the Dutch developed such an appetite for pictures of themselves and of their way of life that their artists had quite enough to do even without working for Calvinist churches, in which all religious painting was now banned. During the seventeenth century Holland probably had more painters, and more art collectors, than any other country. Actually, this boom only lasted for about half the century, but these years form one of the most important chapters in the history of painting. Pictures were as popular then as movies or sports are today, so that many Dutchmen were lured into becoming painters by hopes of success which all too often failed to come true. At times even the greatest artists of Holland found themselves suddenly out of favor with the public and hard-pressed for a living.

Not many Dutch painters traveled to Italy, but several did so in the early years of the century; they are known as the Utrecht School, after the name of their home town. While in Rome these men were so impressed with the style of Caravaggio that they looked at little else. The charming *Lute Player* (plate 71) by Hendrick Terbrugghen, the most talented member of this group, seems to come from the same tavern as Caravaggio's young men; the naturalism, the light, the timing, all remind us of *The Calling of Saint Matthew* (plate 66). These were the things Terbrugghen and his friends brought home with them to Holland, for other painters to see and get excited about. And so they became the connecting link between the art of Caravaggio and the great masters of their own country, who knew better than they did how to put the new Italian ideas to work.

That is what has happened in the wonderfully lively portrait of *Yonker Ramp and His Sweetheart* (plate 66), done in 1623 by Frans Hals, the leading painter of the town

The Triumph of Light

71. HENDRICK TERBRUGGHEN. *Lute Player.*
About 1620–25. National Museum, Stockholm

of Haarlem. It is hard to imagine, for instance, Titian's young nobleman (plate 52) or Holbein's successful and serious George Gisze (plate 64) wanting to be shown like this, drinking and carousing with a lusty bar wench. Yet the young Dutch cavalier of our painting obviously did not mind posing as the main figure in an uninhibited (even undignified) tavern scene. Apparently he wanted liveliness rather than dignity, and Frans Hals has given him more of that than even Caravaggio could have done. Everything here is keyed to the mood of the moment: the laughter, the raising of the wine glass, and—most important of all—the way the picture is painted. Frans Hals has put down his colors in broad, dashing strokes of the brush, never really "finishing" any of the details, so that the completed picture keeps the freshness of a first sketch (compare the one by Rubens, plate 70). We can almost see the artist battling against time, making every split second count. Actually it must have taken Frans Hals hours, not minutes, to do a lifesize painting such as this. What matters is that he wanted us to *think* he did it in the wink of an eye.

For many years Frans Hals was among the busiest and most prosperous portrait painters of Holland, but as he grew older the public turned away from him and he found himself "out of fashion." A similar fate fell to Rembrandt, the greatest genius of Dutch art. In plate 72 you see one of his earlier pictures, painted in 1633, soon after

97

The Triumph of Light

72. REMBRANDT. *Christ in the Storm on the Sea of Galilee*. 1633.
Isabella Stewart Gardner Museum, Boston

he had settled in Amsterdam. For about a decade, it was the height of fashion for the wealthy people of this rich seaport city to have their portraits painted by Rembrandt; he, however, was more interested in religious scenes, of which he made a great many, although for art collectors rather than for churches. The subject of this one is *Christ in the Storm on the Sea of Galilee*. Here Rembrandt shows how close he could come to Rubens' art: the forces of wind and water are clashing so fiercely that they almost seem to merge, crushing the boat between them. For the Dutch, who always felt the threat of the sea, either as sailors or as lowland dwellers, this scene had a very direct bearing on their daily lives; they could easily imagine themselves in the same boat

The Triumph of Light

73. REMBRANDT. *The Polish Rider*. About 1655. The Frick Collection, New York

with Christ, especially since Rembrandt has painted a fishing boat of the kind actually in use during those days. And the followers of Christ are just as scared as ordinary fishermen (one of them is even being seasick). But the most remarkable thing in the picture is the light, which reveals the entire scene to us in a single flash, as though it came from a terrific bolt of lightning. This is Caravaggio's dramatic timing again, put to work by Rembrandt and raised to a new pitch of excitement.

As Rembrandt grew older he became less and less interested in scenes of violent action. Instead, he gained a deeper insight into the drama of people's thoughts and feelings. *The Polish Rider* (plate 73) was done some twenty years after the *Christ in*

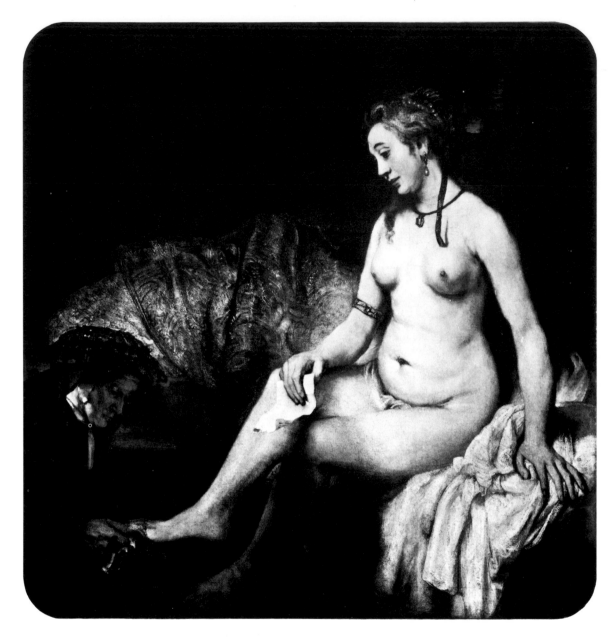

74. REMBRANDT. *Bathsheba*. 1654. Louvre Museum, Paris

the Storm, and in this more personal style. We do not know for sure whether the rider is Polish (the title was given to him later), only that he is dressed in a strange, Eastern-looking costume. Nor can we tell exactly what meaning Rembrandt had in mind for him. Like Dürer, Rembrandt was a print-maker, so he probably knew and admired the famous engraving, *Knight, Death, and Devil* (plate 63). *The Polish Rider* is another "Christian Soldier," bravely riding through a perilous world; but the dangers along the way, and the goal as well, are left to our imagination, instead of being spelled out as in Dürer's print. The gloomy landscape and somber colors suggest that our

The Triumph of Light

"knight" is not having an easy time; his serious alert glance also tells us of unseen dangers, while the determined set of his mouth makes us feel that he will face them with courage.

If *Christ in the Storm* made us think of Rubens, *The Polish Rider* reminds us of Giorgione and Titian. Like them, Rembrandt has now become a poet of light and color, a maker of moods rather than of stories. And yet *The Polish Rider* remains a Baroque picture. Giorgione (plate 50) respects the limits of his canvas, and makes all his forms stay within the frame; with Rembrandt, on the contrary, the frame does not hold anything in place. His horseman is merely "passing through" and will soon be out of sight. And since he moves in the same direction as the light in the picture, we almost come to feel that the light is a kind of force which helps him along. The language of Rembrandt's late style, then, is not so different from that of Rubens after all; he just uses it to say other things.

The magic of light plays an even greater part in Rembrandt's mature religious works, such as the unforgettable *Bathsheba* (plate 74). The Bible tells us that King David fell in love with Bathsheba one night as he watched her in her bath, and he sent a messenger to bring her to his palace. (Later, he made sure that her husband was killed in battle so that he could make her his wife, but the angry Lord caused their first child to die.) Here is a subject ready-made for Rubens, we might think: what a sumptuous picture he would have made of it! But Rembrandt, on the other hand, shows us the meaning behind the story, not the scene itself. His Bathsheba, holding David's note, is not only a beautiful woman, but one of great dignity as well. What is it, we wonder, that makes her so sad? She seems to know already what will happen, and accepts it with resignation. Whatever Bathsheba is thinking, the old woman washing her feet is quite unaware of it. Rembrandt's attention and sympathy are centered on the unhappy Bathsheba. Through the wonderful play of light on her face, he tells us all he has learned during his lifetime about the strange ways of the human spirit.

Paintings like this demand a lot of thoughtful attention if we want to understand them completely. In fact, most of the art buyers of Holland found them too "difficult" for their taste. They much preferred pictures of familiar things and experiences, such as the *Fort on a River* by Jan van Goyen (plate 75), with its view of a distant town, its sailboats and windmills. There is nothing remarkable about this scene—it might be almost anywhere along the Dutch coast—and people loved it just because they knew it so well. Van Goyen, however, is less interested in the details than in the special mood of these low-lying "nether lands" that are always at the mercy of wind and water. His vast gray sky seems calm enough, yet it holds the threat of those same forces whose fury we had seen unleashed in Rembrandt's *Christ in the Storm*.

Like so many artists of seventeenth-century Holland, Van Goyen was a specialist; he painted nothing but landscapes of the type we have just seen. Other Dutch landscape painters favored different moods and different kinds of scenes. Our next picture, *The Jewish Graveyard* (plate 76), is by the most famous of them all, Jacob van

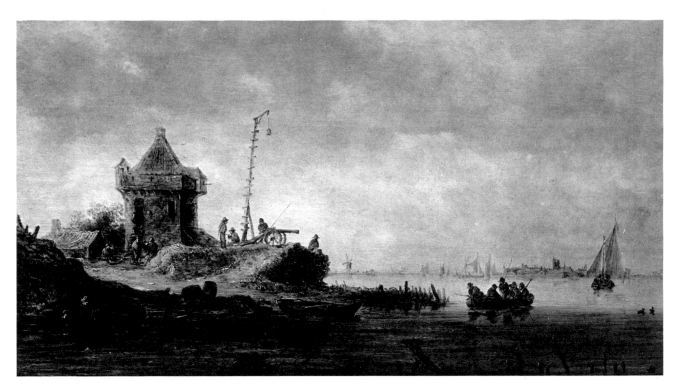

75. JAN VAN GOYEN. *Fort on a River*. 1644. Museum of Fine Arts, Boston

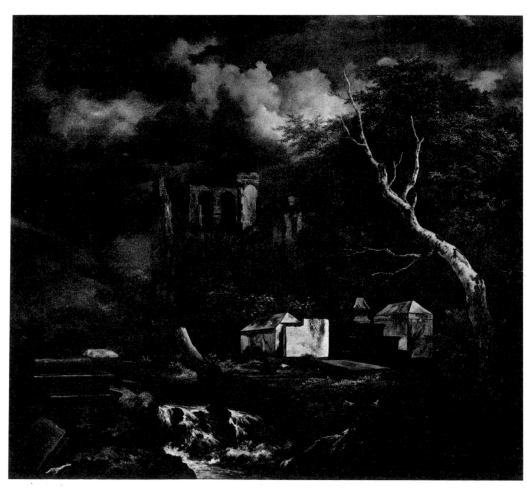

76. JACOB VAN RUISDAEL. *The Jewish Graveyard*. About 1655. Picture Gallery, Dresden

The Triumph of Light

Ruisdael. Here again the forces of nature are the main theme. Although the setting is frankly imaginary, it is carried out with as much— perhaps even more—conviction than if it were an actual place. The thunderclouds passing over the wild and deserted countryside, the ruined building, the rushing stream that has forced its way between the ancient graves, all help to create a mood of deepest gloom. Nothing endures on this earth, Ruisdael tells us; time, wind, and water will grind it all to dust—not only the feeble works of man but trees and rocks as well. He may have felt that way about his own life, for his name appears on the tombstone nearest to us.

Another group of specialists were the "painters of things," whose works we call still lifes. In plate 77 you see a very fine one by Willem Claesz Heda, painted in 1634. Earlier masters had been interested in things, too (look at Holbein's *George Gisze*, plate 64), but only as part of a human subject. Why, then, did the Baroque painters regard still lifes as good enough to put a frame around, and how did they decide what to put into such pictures? In our painting, the silver dish and the great

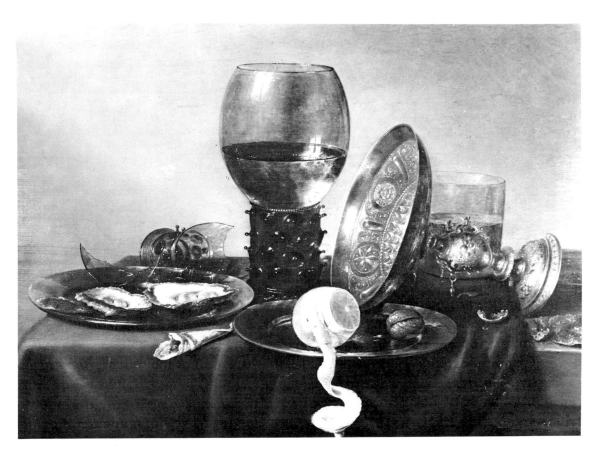

77. WILLEM CLAESZ HEDA. *Still Life*. 1634. Boymans-van Beuningen Museum, Rotterdam

The Triumph of Light

glass goblet are fine and expensive pieces, interesting in themselves; the oysters go with the wine in the goblet, and the lemon goes with the oysters. But the silver dish has been upset, and one of the goblets is broken. Are we meant to wonder why this elegant lunch was left uneaten? Perhaps Heda, like Ruisdael, is trying to tell us that the things of this world don't last very long, since life itself is short. (Dutch still lifes often have secret messages of this sort.) The arrangement as a whole, however, is too tasteful and well balanced to fit any kind of a story. What really "explains" it is the artist's interest in light and its reflections on these varied surfaces. It is this that stamps our still life not only as Baroque but as Dutch Baroque of the 1630s. Compare it with Rembrandt's *Christ in the Storm*, painted a year earlier: you may find it hard to believe that two paintings so different as these could have anything at all in common, yet they share a peculiar silvery tone—the light "feels" the same in both.

Before we conclude our discussion of the art of Holland, let us have a quick look at the genre specialists, painters of daily life among the burghers and peasantry. *The Eve of Saint Nicholas* by Jan Steen (plate 78) shows a family at Christmas time. Saint Nicholas—the Dutch counterpart of Santa Claus—has just visited the children and dealt out presents and punishments; everybody is having a fine time except the bad boy to the left, who got nothing but a birch rod (for punishment) in his shoe. Jan Steen tells this story with great relish, embroidering it with all sorts of warm human touches and delightful details. It all looks very much like the scene that is still acted out in our own homes every year. Few artists have made us feel the pleasures—and pains!—of family celebrations quite so well.

After the cheerful din of Steen's Christmas party, we are struck by the silence and order of *The Artist in His Studio* by Jan Vermeer (plate facing the title page of this book). Both of these pictures were done about the same time—in the 1660s—but this fact only helps to stress the basic difference between them. Steen, the story-teller, has the vivid sense of timing we know from Frans Hals. Vermeer, in contrast, shows us a timeless "still life" world, where nothing stirs, not even the figures. And yet, strange to say, they do not look at all frozen; it is rather as if this room, and everything in it, had been gently becalmed by some magic spell. The cool, clear daylight filtering in from the left provides all the action there is, and all that is needed, as it glances off the model's bright blue gown, sets the brass chandelier aglow, and settles in tiny, dewlike "droplets" on the curtain in the foreground. And now we realize the meaning of the spell: it makes us aware of the miracle of sight. Looking at this picture, we feel as if a veil had been pulled from our eyes, so that everything shines with a freshness and beauty we never knew before. In his early years Vermeer had learned a good deal from the painters of the Utrecht School; through them, he owes a debt to Caravaggio. But the quiet perfection of his style reminds us of something else—of Hubert and Jan van Eyck, the first great "discoverers of reality." In one sense, Vermeer completed what they had begun; yet he is also an important discoverer in his own right. Neglected until quite recently, he seems today far more modern in spirit than any other Dutch painter of his time.

78. JAN STEEN. *The Eve of Saint Nicholas*. About 1660–65. Rijksmuseum, Amsterdam

79. Diego Velázquez. *The Maids of Honor*. 1656.
Prado Museum, Madrid

SPAIN: VELÁZQUEZ

In all of seventeenth-century art, there was only one other painter as completely
devoted to the wonders of seeing as Vermeer: Diego Velázquez, certainly the greatest
master of the Spanish Baroque. As a young man he, too, had come under the
influence of Caravaggio's style: after he was appointed court painter to the King of
Spain, he came to know Rubens and studied the works of Titian. His mature style,
however, is unlike any of these. It can no more be "explained" than that of Vermeer.
Most of Velázquez' works are royal portraits that had to follow set patterns, but
every once in a while he would do a picture entirely on his own, such as *The Maids
of Honor* of 1656 (plates 79, 80). It, too, might be called "the artist in his studio,"
for it shows Velázquez himself at work on a huge canvas, probably the very picture
we see before us. In the center is the little Princess Margarita with her playmates and
maids of honor. Her parents, the King and Queen, have just stepped into the room;
their faces are reflected in the mirror on the back wall, which means that they saw
the scene exactly as we do. In other words, Velázquez has painted a "king's-eye
view" of his studio. But could the King and Queen really have seen *as much* here as
Velázquez shows us? Were they as struck as we are by the soft, shadowy depth of the

106

room? Did they sense the drama of the sunlight flooding the foreground the way we do? Velázquez' brushwork may at first glance remind you of Frans Hals, but you will find it a great deal more varied and subtle, for its aim is not to catch the figures in motion but rather the movement of light *over* the figures. Light, to Velázquez, is what *makes* color and form. That's why he puts so many kinds of light into his picture, to find out how different they make things look—how the colors of a gown can change from warm to cool, and its "feel" from crisp to soft. If we had to pick a single work to sum up the "language" of Baroque painting, we could hardly make a better choice than *The Maids of Honor*.

80. DIEGO VELÁZQUEZ. *The Maids of Honor* (portion). 1656. Prado Museum, Madrid

The Triumph of Light

POUSSIN AND THE FRENCH ACADEMY

Moving on from Spain to France, we find a very different taste at the royal court at Paris. King Louis XIV liked to be called the "Sun King," because he wanted it known that everything in France depended on his will, just as all life on earth depends on the sun. He even wanted to control the way French artists painted, and he did this through the Royal Academy, an official school for painters and sculptors. In the past, young artists had always been trained by working in the shops of older men, and this was still usual during the Baroque era. But since the Renaissance, as we have seen, practical skill and experience were not always enough for the artist. He now needed to know a good deal of science and theory, so certain masters founded private academies where they taught these things to groups of young artists. At the Royal Academy of Louis XIV, practice and theory were combined into a complete system of instruction, with the aim of giving the student an approved standard of style and beauty. This program became the model for all the later academies, and its echoes can still be felt in some art schools today. Even so, it never worked very well. The most important thing in art, after all, is imagination, and it's pretty hard to make rules about that. Artists are by nature "unruly," so the best of them usually stayed outside the academies. In fact, the man on whose work the Royal Academy based its "ideal style" preferred to live in Rome, at a safe distance from the pressure of the Court. He was Nicolas Poussin, the greatest French painter of the seventeenth century. His art was a deliberate reaction against what he considered to be the excesses of such painters as Rubens and Lanfranco. *The Abduction of the Sabine Women* (plate 81), which he did in 1636–37, will show you why the Academy considered him such a perfect example for its students. The subject is a famous event from Early Roman times. In Rome there was at first a great shortage of women, since the city had been founded by an adventurous band of men from across the sea. The Romans tried to find wives among their neighbors, the Sabines, but the Sabine men would not let them. So the Romans used a trick: they invited the entire Sabine tribe into the city for a peaceful festival, then suddenly fell upon them with arms and took the women away by force. Poussin was, of course, interested in this scene as a drama involving many different kinds of action and emotion, all of which he depicts so clearly that they can almost be "read" like a book. At the same time, however, he felt that it must be treated in a noble and heroic manner, so instead of trying to imagine how ordinary people would behave in such a situation he modeled his figures after Classical statues and after the masters of the Roman High Renaissance (compare Raphael's *Heliodorus* mural, plate 49). Still, Poussin was far from blind toward the art of his own day. The flowing movement in his work reminds us of Rubens, and the light has some of the sharpness of Caravaggio's. Drawing and modeling were obviously more important to Poussin than painting—he believed in form as something apart from light and color—yet there is a fine color sense in the *Sabine Women*, and the soft and airy background landscape seems almost Venetian. The entire picture suggests an artist who knew his own

The Triumph of Light

mind almost too well. Poussin's style did not just happen; it grew from conscious effort. His aim, it seems, was an art of the "golden middle ground" where form and color, thought and feeling, truth and beauty, the ideal and the real, are all in harmony with each other. Since this required such discipline and self-control, Poussin's style was considered more "teachable" than that of any other important master. Poussin himself wrote about his work at great length in his letters to friends or patrons. Sometimes he would discuss a single picture, explaining in detail exactly what he had done, and why; or he would set down theories and ideas about painting in general, always confident in his belief that art could be reasoned out like any other subject. The teachers at the Academy followed the same method, taking a picture apart as if it were an intricate piece of machinery. One of them even made up a sort of scoreboard of the great painters from all periods, giving definite grades to each one for composition, drawing, color, and "expression" (in this subject Caravaggio got a zero, the lowest mark!). All this, of course, never produced another Poussin, yet we still admire his work and respect his ideals.

81. Nicolas Poussin. *The Abduction of the Sabine Women*. 1636–37. Metropolitan Museum of Art, New York

82. Benjamin West. *Colonel Guy Johnson.* About 1775.
National Gallery of Art, Washington, D.C. (Mellon Collection)

6

Toward Revolution

When we think of the eighteenth century, the first things that come to our mind are the American Revolution in 1776 and the French Revolution thirteen years later. We are also apt to remember that it was the Age of Enlightenment, the time of the great social thinkers who believed that all human affairs ought to be ruled by reason and the common good—a revolution of the mind that started a good many years before the political revolutions. This is all true enough, yet it gives us a somewhat one-sided view of the times. It was indeed an age of change, but most of the changes happened slowly, rather than from one day to the next, and until quite late in the eighteenth century, life was not so very different from what it had been in the seventeenth. In art, too, the trends that had begun during the Baroque era continued for a long time without any violent breaks. Since we have already seen how freely new ideas in art could cross from one country to the next, it will no longer surprise us to find that we can trace the pageantry of Rubens, the realism of the Dutch masters, the severe ideals of Poussin, even when they appear in other places and under different circumstances.

WATTEAU AND THE ROCOCO

In France, the early years of the century saw a really striking change of public taste. During the reign of Louis XIV, the Royal Academy had controlled much of the art life of the country, and the style of Poussin had been widely imitated. The "Sun King" kept a stern eye upon the manners and living habits of his courtiers for over half a century. When he finally died in 1715, it was as if the entire French Court decided to go on a holiday. The nobles deserted the Royal Palace of Versailles, where they had been forced to live in his day, and built themselves elegant private town houses in Paris. These they had decorated by artists who had broken with the old tradition of the Academy. Their hero was no longer Poussin but Rubens, who to them represented all the things the Academy had frowned upon: color, light, movement, and a frank pleasure in living.

Antoine Watteau, who came from the northern border of France near Flanders, was the first, and by far the most gifted, painter of this new era, which we often call the Rococo. His *Mezzetin* (plate 83), done about 1715, shows us a character out of Watteau's favorite subject, the popular comedy theater of the time. His easy, flowing brushwork and splendid color leave no doubt in our minds about the influence of Rubens on him, even though Watteau lacks the sweeping energy of the great Fleming. Instead, we find delicate, slender forms and a mood, half gay and half sad, that may remind you a bit of Giorgione's *Concert* (plate 50). Watteau, however, has made the situation far more pointed: Mezzetin is an actor doomed to serenade his lady-love without hope, both on the stage and in real life—we recognize him as a relative of

83. ANTOINE WATTEAU. *Mezzetin*. About 1715. Metropolitan Museum of Art, New York

those sorrowful clowns that have survived till today in such popular successes as the opera *I Pagliacci.*

Watteau's love of the theater gives us a clue to the spirit of Rococo society. It was, for the nobles at any rate, an age of play-acting—of pretending that their life was as free from worry as that of François Boucher's shepherd and shepherdess (plate 84), who live in a delightful world where no sheep ever strays, so they can spend all their time in the pursuit of love. Marie Antoinette, the last Queen of France, actually had a model farm built on the grounds of the Palace of Versailles, where she and her friends could play at being milkmaids and field hands when they got tired of the formality of court life.

FRENCH PAINTING FOR THE COMMON MAN

There was, however, another side to French eighteenth-century painting, especially during the thirty years that ended in the Revolution. It reflects the growing importance of the common man, who, as the "citizen" of 1789, was to become the ruler of France. In 1761, while Boucher was still catering to the taste of the nobles with his powdery shepherds and shepherdesses, Jean-Baptiste Greuze painted *The Village Bride* (plate 85), a subject based on the daily life of the people, which was acclaimed a masterpiece. He had been trained in the Rococo style, but he broke with his own past and turned to the realistic genre painters of Holland for inspiration. His reasons for picking a scene like this, however, were quite different from those of the Dutch masters. Steen's *Eve of Saint Nicholas* (plate 78) strikes us as a real event, observed with humor and sympathy, while *The Village Bride* is "staged" by actors. The bride looks too bashful, her mother too tear-stained, the grandfather too venerable to be quite convincing. We feel that Greuze wants to pull our heartstrings at all costs—"Just look how touching, how sincere these poor people are!" he seems to say. Every detail in the picture plays a part in this message, even the hen with her chicks: one of them has left the brood and is sitting alone on the saucer to the right, just the way the bride is leaving *her* "brood." Sincere emotion has degenerated into bathos here. Strangely enough, the loudest praise for *The Village Bride* came from the most "enlightened" minds—from the advocates of the rule of reason. These men liked it that everything in Greuze's picture "meant" something, and that the artist wanted to appeal to our moral sense instead of just giving us pleasure, like the Rococo painters. Of course, they overlooked the fact that a worthy moral is not enough—and isn't even necessary—to make a great work of art.

We can learn the truth of this from *Kitchen Still Life* by Jean-Baptiste Siméon Chardin (plate 86). Its meaning is similar to Greuze's, but it is conveyed to us without preaching or acting, yet far more effectively. Chardin, too, admired Dutch painting, and his picture comes from such earlier still lifes as the one by Heda (plate 77). However, instead of using expensive silver dishes and hand-blown glass, he picked a few plain, sturdy kitchen pieces and some uncooked meat and fowl—the household things

84. François Boucher. *Shepherd and Shepherdess*. 1755.
Louvre Museum, Paris

85. Jean-Baptiste Greuze. *The Village Bride*. 1761. Louvre Museum, Paris

86. Jean-Baptiste Siméon Chardin. *Kitchen Still Life*. 1735. Museum of Fine Arts, Boston

of the common man. Chardin has found so much intrinsic beauty in these simple everyday objects, he treats them with such respect and understanding, that they suddenly become important as symbols for a way of life. Somehow, we feel, his quiet and unassuming picture has attained all the dignity and simplicity that Greuze tried, in vain, to put into *The Village Bride*. And the reason is that Chardin speaks directly to us in the painter's own language—through color, light, and form—instead of borrowing the language of the stage.

THE RISE OF ENGLISH AND AMERICAN PAINTING

During those years many Frenchmen had a great admiration for England. The English had gone through a time of political revolution in the seventeenth century; they had forced the King to hand most of his powers over to Parliament, so that the "common Englishman" already had a voice, although a limited one, in his own gov-

116

ernment. As a result, England became the envy of the continental nations. Its wealth was growing rapidly, the overseas colonies prospered, and the British navy and merchant fleet ruled the seas. Last but not least, the English had begun to play an important part in the fine arts.

Since the time of the Reformation, there had been little painting in England except portraits, and the leading artists had been foreigners: Holbein under Henry VIII, and later on, Flemings and Dutchmen. The earliest important English artist of the eighteenth century was William Hogarth. He taught moral lessons by painting pictures in series, as if the action was taking place on stage. This flair for the theater reminds us of Watteau, and French art was an important influence on English painting. At the same time, these English "morality plays" later affected such French artists as Greuze. Unlike Greuze's *Village Bride*, Hogarth's *Orgy* (plate 87) teaches solid virtues by showing us bad examples. In this scene from the series *The Rake's Progress* we

87. WILLIAM HOGARTH. *The Orgy*, Scene III from *The Rake's Progress*. About 1734.
Sir John Soane's Museum, London

see a young man indulging in pleasure, though we can be sure from many things in the picture that he will later have reason to repent his sins. If the moral statement is all too obvious, the painting nevertheless has great appeal. Hogarth tells the story with the relish of Jan Steen, while adding the sparkle of Watteau. The scene is so entertaining that we enjoy the sermon anyway.

Another English artist fascinated by the theater was the Swiss-born Henry Fuseli, who painted many scenes from plays by Shakespeare. The left side of *Titania's Awakening* (plate 88) captures to perfection the fanciful spirit of *A Midsummer-Night's Dream.* But on the right side we find a nightmare which departs entirely from Shakespeare's text. Fuseli was interested in the dark world of dreams; he greatly affected other artists through his forceful personality. Although his strange mind looks forward to Romanticism, Fuseli restrained his imagination by imposing the discipline of tradition on his paintings. His figures show the influence of Michelangelo and the Mannerists.

Even in the eighteenth century, when English artists came to the fore again, portraits were all they could count on for a steady living; but many of them did other subjects as important sidelines, so that these, too, came to be at home in England. The most famous portrait painter of eighteenth-century England, Thomas Gainsborough, created wonderful landscapes. For instance, in his portrait of *Robert Andrews and His Wife* (plate 89), he has made the outdoor setting as important as the sitters. The cloudswept view will remind you of Dutch landscapes, such as those in plates 75 and 76, but now the forces of nature seem gentle, rather than threatening. This land belongs to the country squire and his lady, and they, in a sense, belong to it. Gainsborough here suggests the charm of a country life that is real, not make-believe as in Boucher's picture (plate 84).

The North American colonies were by now old enough to have some fine painters of their own. The two most gifted ones, however, did not remain at home long enough to witness America's coming-of-age. A few years before the American Revolution, Benjamin West, a Pennsylvania Quaker, and John Singleton Copley, from Boston, went to London, where they had such success that they stayed on for good. West even became court painter to King George III, and president of the British Royal Academy of Painting. This Academy, like the French Academy, was patterned on the principles of Poussin, but its ideals were much less severely Classical; in fact, they were broad enough to include the art of Rembrandt. West's portrait of *Colonel Guy Johnson* (plate 82), painted about 1775, is bathed in a light of Rembrandt-like warmth, although we miss the Dutch master's expressive force. The poses of both figures, on the other hand, seem a bit self-consciously heroic, as if the two were Ancient Romans, while the costumes, and all the other trappings, are faithfully observed, down to the last detail. Colonel Johnson was one of our first superintendents of Indian affairs. He is shown here with his trusted friend, Thayendanegea, who looks very much like "the noblest redskin of them all." West must have been quite proud of his American background, since he stressed all the little touches of frontier life (including the Indian encampment on the left) which no European painter could have known so well.

88. HENRY FUSELI. *Titania's Awakening*. About 1790.
Art Museum, Winterthur, Switzerland

89. THOMAS GAINSBOROUGH. *Robert Andrews and His Wife*. About 1750. National Gallery, London

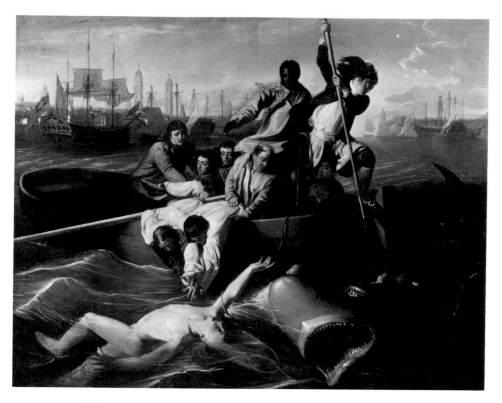

90. JOHN SINGLETON COPLEY. *Watson and the Shark*. 1778.
Museum of Fine Arts, Boston

This sense of adventure is even more striking in Copley's *Watson and the Shark* (plate 90) of 1778. The picture is based on Mr. Watson's own account of his gruesome accident, which happened in the harbor of Havana and cost him a leg before he was pulled aboard the boat. Of course the scene did not look exactly as depicted here, but then Copley did not mean to reconstruct it detail by detail. What he wanted was to make it as thrilling as possible, and he has used every trick of the Baroque style to this end. The action has all the drama of Rubens, and Caravaggio himself could hardly have "timed" it better. Yet behind all this we feel an imagination that carries the flavor of the New World rather than of the Old.

DAVID AND THE FRENCH REVOLUTION

The American Revolution was fought for one of the same reasons that later brought on the Revolution in France: unfair taxes imposed on the people by a government in which they had no voice. It is one of the bitter jokes of history that the French King aided the Colonists' struggle for freedom, seeing in it a chance to weaken the power of England. Their success in America may well have been the last bit of fuel that brought the French pot of political troubles to a boil. Criticism of the weak and corrupt government, and attacks on the holders of special privilege, had been growing for a long time in France. We have seen signs of this in Greuze's *Village Bride*, where the honesty and goodness of the poor is meant to show up the moral decay of the aristo-crats. Other painters went even further. Among the most important was Jacques Louis David, who took a very active part in the Revolution and became its "official" painter. He depicted the stories of heroic defenders of freedom in Ancient Athens or

Toward Revolution

Rome, conveying the idea of "give me liberty or give me death." *The Death of Socrates* (plate 91) shows the Greek philosopher about to drink the cup of poison hemlock rather than renounce his democratic ideals. This example of Ancient virtue was meant to inspire the French public in its struggle for liberty, and Socrates is painted as a Christ-like figure (there are twelve disciples in the scene) who sacrifices himself for the common good. Even the style of the picture carries a moral message. Based on the severe, "ideal" style of Poussin, it was a rebuke to painters like Boucher, who had modeled their works on Rubens and were now scorned as mere pleasure-seekers with nothing worthwhile to say. (The terms Baroque and Rococo were coined at this time as unflattering labels.) The "anti-Rococo" painters, however, were even more rigid in their admiration for Ancient art than Poussin had been, and we call their work Neo-Classic. The figures in David's harsh design are as solid and stiff as statues. Every pose and expression can be "read" even more clearly than those in Poussin's *Abduction of the Sabine Women* (plate 81). Yet the artist has added something unexpected: he has taken over the sharp lighting and realistic detail from Caravaggio (compare plate 67). The picture therefore has an astonishing quality of life, which suggests how passionately David was engaged in the issues of his day. Just as the artists of the Renaissance had helped to bring about a new era in science, so the Neo-Classic artists had a share in paving the way for the new political era that began with the French Revolution.

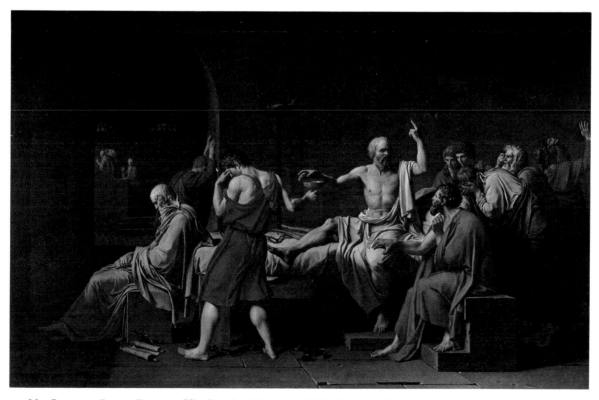

91. JACQUES LOUIS DAVID. *The Death of Socrates*. 1787. Metropolitan Museum of Art, New York

The French Revolution, which began in 1789, had replaced the King with a republican government. The Republic, however, lasted only a decade. Before the century was out, France was again ruled by one man. Napoleon Bonaparte had risen to power as the leader of the Republican armies when the nation was attacked by its neighbors, who feared that the slogans of the Revolution—Liberty, Equality, and Fraternity—would soon catch on with their own people. The military genius of Napoleon conquered them all, except for England. He then made himself Emperor, a thousand years after Charlemagne. But in another ten years, in 1814, his army was beaten by the united forces of England, Germany, and Russia, and he was a prisoner.

THE ERA OF NAPOLEON

Napoleon is another of the bitter jokes of history. In order to defeat him, the other countries had to take over a good part of the revolutionary ideas they had been so afraid of. For Napoleon did not undo the results of the Revolution; he simply used them for his own ends. His was the first modern army—a mass army of citizen soldiers fired by a feeling of patriotic duty. His enemies, who fought him at first only with soldiers hired for money, had to create mass armies, too; and having asked this common sacrifice of everybody, they found it more and more difficult to resist people's demands for more rights. Under Napoleon, a man rose in rank because of what he could do, not because he came from a noble family; here again the Emperor set an example to those countries where personal ability was less well rewarded. No wonder, then, that after the Napoleonic wars the common man felt greater confidence in his own powers and in his claim to those hard-won rights that Americans had been enjoying ever since 1776.

Napoleon fancied himself an Ancient Roman Emperor reborn. And the French painters who, before and during the Revolution, had preached the heroic virtues of the Ancient republics, now took the elegance and splendor of Imperial Roman art as their model. David himself had been one of the earliest and most ardent admirers of Napoleon, but he no longer held the same commanding position as before; a number of younger artists, who had grown up with the Revolution, were now beginning to take the lead.

Meanwhile the Baroque-Rococo style, with its emphasis on imagination rather than "truth," and on light and color rather than form, had never died out completely. There were artists in Napoleon's day who painted Neo-Classic ideas in a Baroque way, while others took over the Neo-Classic language but used it for highly imaginative, even fantastic subjects. One very important painter, the Spaniard Francisco Goya, even managed to turn the Baroque into a "modern" style without being touched by the Neo-Classic trend at all. Like Velázquez, whose art he greatly admired,

Goya was the official painter of the Spanish king, although from the very start he did a great many things besides court portraits. Perhaps his most powerful works are those devoted to the struggle of the Spanish people against the army of Napoleon, which had occupied the country but never really conquered it. In *The Third of May, 1808* (plate 93), he shows the shooting of a group of Madrid citizens who had resisted the foreign invaders. The blazing color, the broad "handwriting" in paint, the dramatic light, all remind us of the Baroque. Why then do we feel so strongly that the picture belongs to the early nineteenth century in spirit? The subject itself, of course, is new and daring, but the way Goya has treated it is even more so. David's *Socrates* (plate 91) had reminded us of a religious painting; *The Third of May, 1808* makes equally full use of the devices of religious art—Goya had been deeply impressed with the work of Rembrandt—and again people are dying, not for the Kingdom of Heaven but for Liberty. For Goya, however, the real tragedy was that the shooting should be done by the French. Like so many others, he had thought at first that the forces of Napoleon would carry the ideals of the Revolution into his own backward country. *The Third of*

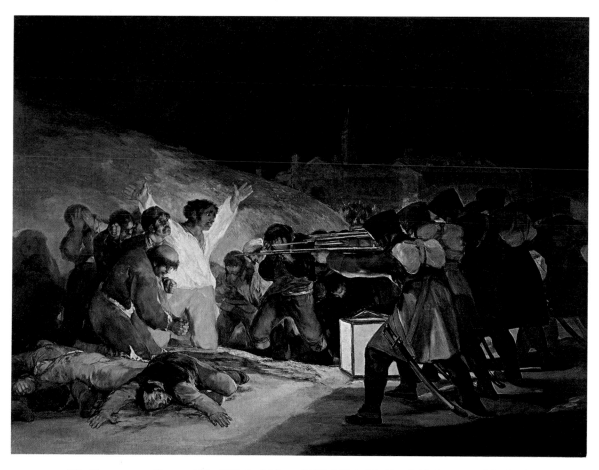

93. FRANCISCO GOYA. *The Third of May, 1808*. 1814–15. Prado Museum, Madrid

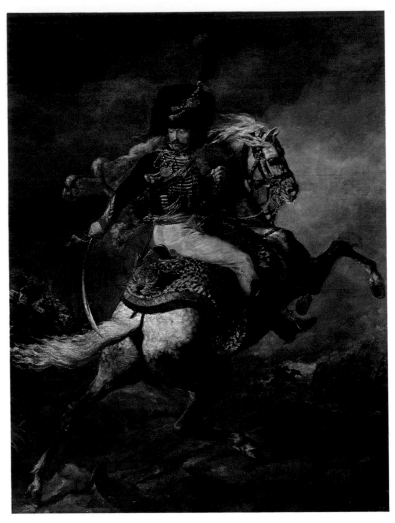

94. Théodore Géricault. *Mounted Officer of the Imperial Guard.*
1812. Louvre Museum, Paris

May, 1808 is a memorial to Goya's shattered hopes—and to those of countless others in the years to come. This same scene has been repeated so many times since Goya's day, always with a different cast of characters and in countries all over the globe, that it has become a terrifying symbol of the "era of revolutions."

Let us now turn to the *Mounted Officer of the Imperial Guard* (plate 94), to see how a young French painter felt about Napoleon. This life-size picture was done in 1812 by the marvelously talented Théodore Géricault, then only twenty-one years of age, as a sort of ideal portrait of the Napoleonic soldier. Born a generation later than David and Goya, Géricault had a very different viewpoint. For him, politics no longer had the force of a faith; what he saw in the Emperor's military campaigns was the color and swirling excitement of violent action. These, of course, were just the things that could not be well expressed in the Neo-Classic style, so our artist has gone all the way back to Rubens for his source of inspiration (compare the dramatic *Crucifixion* by the older master in plate 69). Goya had still belonged to the tradition of Baroque art; Géricault did not, but he revived it, as the style best suited to his own temperament. With him we meet a new type of painter, and an important and vital new movement in art called Romantic.

The Age of Machines

ROMANTIC PAINTING IN FRANCE, ENGLAND, AND GERMANY

The word Romantic actually comes from the field of literature, where "romances" (that is, stories of adventure) were very popular at that time, so that it describes a state of mind rather than a particular style of painting. Few Romantic painters came as close to the full-blown Baroque as Géricault in his *Mounted Officer*, but they all shared a similar outlook. We have seen that such artists as Henry Fuseli had already explored the realm of the imagination in the eighteenth century (plate 88), but they never really "broke the rules" established for art since the Renaissance. Art to the Romantics did not mean a fixed ideal, the way it did to the Neo-Classic artists. There was no such thing as a single "perfect" style for them. What mattered in art and in life, they felt, was not the *kind* of experience you had but how strongly you felt about it. One might almost say that the Romantics sought emotion for emotion's sake. They believed in living dangerously, or at least thrillingly (and sometimes theatrically). Géricault, for instance, was an ardent horseman and died after a bad fall at the early age of thirty-three. As born rebels against any kind of set rules or values, the only thing they held sacred was the individual personality; and since they could express nobody's viewpoint but their own, people often found them hard to understand. In fact, the Romantics enjoyed being misfits in the society of their time. Here, then, you see the beginning of a split between artist and public that still persists today.

Just before Géricault's death, another fine Romantic painter appeared on the Paris scene: Eugène Delacroix. His *Death of Sardanapalus* (plate 95), painted about 1827, has a great deal in common with Géricault's *Mounted Officer*. Here again we find the Rubens-like energy of movement, the open brushwork, the thrill of violent action. The glamorous days of Napoleon and his Empire were now only a memory, so that Delacroix had either to go to some remote place or turn to exotic history and literature—in this case, to a poem written by Lord Byron in 1821—for the kind of subject that excited his imagination. This scene was freely invented without any models, though later on he did visit the Arabic world of North Africa.

In the meantime the mantle of David had descended on his prize pupil, Jean-Auguste Ingres. He and Delacroix remained at opposite poles of French painting until well past the middle of the century—they were "professional enemies," so to speak. At first Ingres, the great conservative, won all the honors and prizes; Delacroix caught up with him in the end, when people had grown used to the Romantic movement. History painting as Poussin had defined it remained Ingres' life-long ambition, but he had great difficulty with it, while portraiture, which he pretended to dislike, was his strongest gift and his steadiest source of income. As a faithful believer in the Neo-Classic theories of David, Ingres regarded himself first of all as a draftsman and designer. Since color and light were to him less essential, he carefully avoided the broad flowing brushwork of the Baroque masters. Yet he was much more of a "painter's painter" than he thought. In his *Odalisque with a Slave* (plate 96)—"odalisque" is a Turk-

95. EUGÈNE DELACROIX. *The Death of Sardanapalus*. 1827. Louvre Museum, Paris

96. JEAN-AUGUSTE INGRES. *Odalisque with Slave*. 1839–40.
Fogg Art Museum, Cambridge, Massachusetts

97. JOHN CONSTABLE. *The Hay Wain*. 1821. National Gallery, London

ish word for a harem slave girl—the colors are extremely beautiful and transparent. The poetic mood is just as important as the finely balanced design in holding the picture together. It could almost be a scene from the *Thousand and One Nights*. Although Ingres worshiped Raphael, this nude is hardly Classical in her beauty. Her elongated proportions and easy grace remind us instead of Mannerism. Whether he admitted it or not, Ingres was just as Romantic as Delacroix, only in a different way.

Both Géricault and Delacroix had been much impressed by English painting. England, where Romantic literature had had its start, produced an important group of landscape painters at the beginning of the nineteenth century, all Romantic in temperament. What Rubens was to the French Romantics, the Dutch Baroque landscape masters were to these Englishmen. In them they found a feeling, similar to their own, for the majestic forces of nature and for man's loneliness and insignificance when faced with these forces. Even so, they did not simply imitate their models, any more than the French copied Rubens. You can tell this from *The Hay Wain* (plate 97) by John Constable, painted in 1821. Constable also made countless oil sketches, most of them no larger than this page. They were done very quickly and on the spot, a new and unusual idea at the time; that is why our picture looks so different from Van Goyen and Ruisdael (plates 75, 76). The Baroque masters had never painted landscapes out-of-doors, even when they wanted to depict a particular place. They only made drawings, which they could then work up in the studio at their leisure. Constable, however, was so fascinated by the ever-changing moods of nature that these

98. WILLIAM TURNER. *The Fighting Téméraire Towed to Her Last Berth*. 1838.
National Gallery, London

changes became far more important to him than the things that stayed the same in a given view. In the painting reproduced here, he has caught a particularly splendid moment—a great sweep of wind, sunlight, and clouds playing over the spacious landscape. At the same time, there is an intimacy in this monumental composition that reveals Constable's deep love of the countryside. This new, personal note is characteristically Romantic. Perhaps the scene did not look quite this way in reality, but since Constable has painted it with such conviction, we see it through his eyes and believe him.

With William Turner, the other great English landscapist of Constable's time, we often find believing rather more difficult. In *The Fighting Téméraire* (plate 98) of 1838, he shows us a famous old warship, once the pride of the British navy, being towed to her last berth against the light of a brilliant sunset. With his philosophical and poetic cast of mind, Turner raises the event to a universal significance. These fireworks in the sky are like a last salute at the burial of a hero who is going down in glory, as the sun does itself. Let us also notice (because Turner intended us to) the contrast between the squat, monster-like tugboat and the tall, silvery *Téméraire*. All this is a splendid

The Age of Machines

show, but it may make some of us feel that Turner, like an over-zealous organist, has pulled out a few stops too many, so that the music becomes deafening.

Landscape painting may have been the most original part of the Romantic movement in art. At any rate, it was the most popular. While Constable and Turner, each in his own way, show us the Romantic view of nature more clearly than anyone else, we find many others all over Europe doing similar things until far into the second half of the century.

In Germany, too, landscape was the finest achievement of Romantic painting. Caspar David Friedrich—perhaps the country's greatest painter since Dürer, whose work he revered—shared many of Turner's attitudes toward life. *Moonrise over the Sea* (plate 99) shows three people looking at some ships coming into harbor. These are not ordinary ships, however, they are symbols of the people themselves as they near the end of their voyage through life. Although the theme reminds us of *The Fighting Téméraire*, the scene is painted without a hint of Turner's "tinted steam" (as Constable called it). Instead, Friedrich uses a careful naturalism stemming from Neo-Classic art. The haunting light reflects his melancholy and sense of mystery before nature.

99. Caspar David Friedrich. *Moonrise over the Sea.* 1823. National Gallery, Berlin

100. GEORGE CALEB BINGHAM. *Fur Traders on the Missouri*. About 1845. Metropolitan Museum of Art, New York

AMERICA

The New World, too, had its Romantic landscape artists, even though most Americans were far too busy carving out homesteads to pay much attention to the poetry of nature's moods. Nature was everywhere, and while it could be frightening it played a special role in the United States. Because it determined the American character, or so it was thought, it became a symbol of the nation. *Fur Traders on the Missouri* (plate 100) by George Caleb Bingham shows this closeness to the land. The picture is both a landscape painting and a genre scene. It is full of the vastness and silence of the wide-open spaces. The two trappers in their dugout canoe with a black fox chained to the prow, soundlessly gliding downstream in the misty sunlight, are entirely at home in this idyllic setting and carry us right back to the river life of Mark Twain's childhood, to Tom Sawyer and Huck Finn.

The Age of Machines

MACHINES AND MODERN LIFE

But let us return from the American wilds to the noise and unrest of the mid-nineteenth century. In the years since the French Revolution, another and even greater revolution had been going on everywhere: the revolution in industry that came with the use of machines. There had, of course, been machines all along, but their usefulness had been limited because they ran only on wind power (which was unreliable) or water power (which had to be used on the spot). The invention of the steam engine in the late eighteenth century changed all that. Now the knowledge that natural scientists had been gathering ever since the Renaissance could be put to practical use in thinking up machines for an endless variety of purposes. This, in turn, led to more discoveries and inventions, right down to the technical miracles of our own time.

It is hard for us today to realize how completely steamboats, railroads, and factories unsettled everybody's way of life a hundred and fifty years ago. People marveled at the flood of cheap and plentiful goods made or shipped with the aid of machines, but the same machines also caused a good deal of human misery. The trained craftsmen of old were thrown out of work and their places taken by masses of industrial workers, unskilled, badly paid, and crowded together in unhealthy slums. No wonder the machine was welcomed by some as a blessing while others called it a curse. Altogether, the rise of modern industry overthrew a great many beliefs, habits, and institutions. It created new tensions and conflicts, yet at the same time it made people more dependent on each other's labor than ever before.

DAUMIER AND COURBET

And what of the painters? What effect did the new thinking and new ways of life brought about by the Age of Machines have on them? One of the first artists to explore modern life was Honoré Daumier. Daumier worked mostly as a newspaper cartoonist. Only late in life did he become a painter, and his pictures were almost completely unknown until after his death. Daumier showed everyday life in the city. In *The Third-Class Carriage* (plate 101) he has captured a strangely modern condition, "the lonely crowd." Though the passengers are packed together, each one is lost in his own thoughts and pays no attention to the people around him. Daumier shows us this with an insight into character and a breadth of human sympathy that is worthy of Rembrandt.

The Romantics had put freedom of feeling and imagination above anything else; but other painters thought this freedom was just an easy way to escape from the realities of life. They believed that in a period of scientific, social, and industrial progress, art should only deal with contemporary subjects. In 1848 a wave of revolutions swept over Europe, inspired by the demand of the lower classes for higher wages, better living conditions, and a more democratic society. These Realist painters began to make serious portrayals of the lives of workers and peasants. Their leader was

133

101. HONORÉ DAUMIER. *The Third-Class Carriage*. About 1862. Metropolitan Museum of Art, New York (Bequest of Mrs. H. O. Havemeyer, 1929. The H. O. Havemeyer Collection)

102. GUSTAVE COURBET. *The Stone Breakers*. 1849. Picture Gallery, Dresden

The Age of Machines

Gustave Courbet, whose *Stone Breakers* (plate 102), painted in 1849, started an uproar similar to the one Caravaggio had caused two and a half centuries earlier. Here we find no "noble ideals," no flights of fancy, only an old man breaking up rocks, aided by his young helper. We learn little about them as persons, since their faces are turned away from us, yet we feel sympathy and respect for them right away because they are so solidly and monumentally *there*. The modern artist, Courbet believed, must stay firmly on the ground of everyday life; he must paint only what he can see directly, not what appears in his mind's eye; he should try to rival the Old Masters, but only in ambition, not by imitating them.

MANET, IMPRESSIONISM, AND IMPRESSIONIST PAINTERS

Despite Courbet's beliefs, his own painting technique still reminds us a good deal of the seventeenth century. He was more interested in the new things he wanted to say than in finding a new way to say them. The new way was discovered by another great French painter, Edouard Manet. He shared Courbet's idea that one should paint only what the eye actually sees, but to accomplish this he had to re-think for himself the whole language of painting. So he began by learning everything he could about this language; he made copies and studies after the Old Masters, and for several years these "pictures of pictures" were his main concern. You can see the new language Manet worked out for himself if you compare his *Fife Player* of 1866 (plate 92) with Courbet's *Stone Breakers*. Since the Late Middle Ages, when pictures first became "windows," painters had always relied on modeling and shading to make their shapes look round and solid, and the spaces around the shapes look deep and hollow. Courbet, too, still painted that way. Manet, on the other hand, decided that all this could be done through differences of color, not through different shades of light and dark. In his *Fife Player*, the light hits the forms head-on, so that we see practically no shadows and no shading. The whole picture is made up of separate, flat, color patches placed next to each other on the canvas. And every patch, whether it stands for a thing (such as a part of the boy's uniform) or just for empty space (like the light gray "patch" around the figure) has a clear-cut shape of its own. What this means is that for Manet the picture has become more important than the things it represents. The limited world of the canvas, he found, has its own "natural laws," and the first of these is that every brush stroke, every color patch is equally "real," no matter what it stands for in nature. Among the Old Masters, Vermeer and Velázquez had come closest to this idea of "pure painting." It remained for Manet, however, to turn the Baroque triumph of light into a triumph of color.

In the Boat (plate 103), painted eight years after the *Fife Player*, shows you the next stage of the revolution Manet had started. Stimulated by younger artists (Claude Monet and others), who carried his ideas further in their own canvases, Manet turned to outdoor scenes such as this, flooded with sunlight so bright that all earlier paintings seem murky by comparison. Color is everywhere, especially in the shadows (if we can

103. EDOUARD MANET. *In the Boat*. 1874. Metropolitan Museum of Art, New York

call them that!). Manet gives us only a casual glimpse of the two people and what they are doing. His brushwork has become quick and sparkling, like that of Hals or Constable (compare plates 66 and 97), so that the entire scene seems in motion. This made the conservative critics call the new style Impressionism, since to their eyes such pictures were at best no more than quick impressions, unfinished sketches not worthy of serious attention. Moreover, they complained, the color was so raw that it hurt their eyes (did they never go outdoors on sunny days?). One of the younger Impressionists, Auguste Renoir, was particularly successful in using the technique of Impressionism to catch the bustling life of the Paris streets, as you can see in his *Pont Neuf* (plate 104) of 1872. It shows one of the bridges over the river Seine in the blazing noonday sun of mid-summer, and again it is the wealth and brilliance of color that gives the picture such charm and gaiety. The air quivers with the heat reflected from the pavement, but the shade seems deliciously cool—altogether a perfect day for a downtown stroll.

Unlike other members of the group around Manet, Edgar Degas hardly ever painted out-of-doors. Among the favorite subjects of this "indoors and nighttime Impressionist" were scenes of the theater and show business, such as his *Café Concert* (plate

The Age of Machines

105) of 1876–77. The bright colors of the costumes, the dramatic lighting, and the contrast between the "artificial" world of the stage and the "real" world of the spectators have been woven into a wonderfully rich and vivid pattern. Again we get what seems to be almost a chance view, as if the artist had sketched it in a few minutes' time while passing through the crowded hall. But this unstudied, off-center look actually hides a lot of hard work and exact planning. Notice, for instance, how the string of lanterns to the left of the singer in the red dress helps to draw attention to her outstretched arm; how the neck of the bass fiddle sticks out of the orchestra pit in exactly the right spot to make us realize the gap in space between foreground and background. The picture is put together with all the care of an Old Master, but an Old Master who has a thoroughly modern mind.

104. AUGUSTE RENOIR. *Le Pont Neuf*. 1872. National Gallery of Art, Washington, D.C. (Ailsa Mellon Bruce Collection)

105. EDGAR DEGAS. *Café Concert: at Les Ambassadeurs.* 1876–77. Museum, Lyons

The Age of Machines

CÉZANNE, SEURAT, AND POST-IMPRESSIONISM

Among Manet's earliest admirers was a rather gruff young man from the South of France named Paul Cézanne. He quickly took over the new language of such pictures as *The Fife Player* and made it the basis of his own work. In the early 1870s Cézanne began to do brightly lit outdoor scenes similar to Manet's *In the Boat* and Renoir's *Pont Neuf*, but he never shared his friends' interest in the "spur of the moment," in movement and change. Toward 1880 he left Impressionism behind and became the first of the Post-Impressionists. This is not a very telling label for the mature Cézanne and those who were in sympathy with his efforts, but at least it suggests that they were not "anti-Impressionists." All these men knew how much they owed to the revolution that Manet had brought on; they were certainly not trying to undo it. On the contrary, they wanted to carry it further in various directions, so that Post-Impressionism was actually just a later stage—though a very important one—of the same basic "Manet Revolution," as we might call it.

Let us see now what kind of Post-Impressionism Cézanne had arrived at. His still life *Fruit Bowl, Glass, and Apples* (plate 106) has the fresh color and free brushwork we have come to expect of an Impressionist picture, but after you look at it for a while you will notice all sorts of puzzling things. There are dark outlines drawn around most of the shapes, and the shapes themselves have been made simpler than they would be in nature; the table top seems to tilt upward, and the foreshortening of the bowl and glass is not "correct." Also, the colors seem to follow a scheme that stresses the contrast between cool and warm tones, and the brush strokes form a sort of pattern that runs over the entire canvas and gives it a shimmering effect. Has Cézanne done all this on purpose, or didn't he know any better? Curiously enough, the longer we study the picture, the more we come to feel that these things look "right" in it, although they are "wrong" according to nature. And that is exactly what Cézanne wanted us to feel. For him, even more than for Manet, a framed canvas was a separate world, with laws of its own that were more important to him than the laws of nature; he could not take something out of nature and put it into a picture without changing it so as to make it fit in. "Bowls, glasses, and fruit," he seems to be telling us, "are not at all remarkable in themselves. We see them every day. They become remarkable only because of what I do with them in my picture. That is my task, my challenge as an artist." But Cézanne did not think of nature simply as his raw material, to be dealt with as he pleased. He had the greatest respect for it and did not change it any more than he felt he had to. In his *Fruit Bowl* you can see how delicately he balances the claims of art and nature: his forms are arranged in depth, yet they also cling to the surface; they are simpler and clearer than they are in nature, since the world of painting is more limited and orderly, being made up of color patches rather than atoms. The forms are carefully related to each other and to the size of the canvas, yet they always remain part of the larger world outside, which does not stop at the frame of the picture.

106. PAUL CÉZANNE. *Fruit Bowl, Glass, and Apples*. 1879–82. Collection Lecomte, Paris

Cézanne once explained that his aim was "to do Poussin over again, but from nature," which meant that he wanted an art as solid and monumental as that of the Old Masters, without giving up what he had learned from Impressionism. The same words might be used to describe the work of Georges Seurat, another great Post-Impressionist. Seurat's career was as brief as those of Masaccio, Giorgione, and Géricault—he died in 1891 at the age of thirty-two—and what he achieved in that short time is just as astonishing. His main efforts went into a few very large pictures, and on each of them he spent a year or more. One reason why he worked so slowly was his belief that art ought to be based on a "system"; his teacher, like Degas', had been a follower of Ingres, and Seurat's interest in theory came from this experience. But his theories, as with all artists of genius, do not explain his pictures; it is the pictures, rather, that explain the theories.

In *A Sunday Afternoon on the Grande Jatte* (plate 107) Seurat has picked a subject pop-

140

The Age of Machines

ular with the Impressionists—a gay crowd enjoying a summer day on an island near Paris. The colors, too, are of the same rainbow-brightness we saw in Renoir's *Pont Neuf*, but otherwise the picture is the very opposite of a quick "impression." Seurat, even more than Cézanne, sought to regain calmness and monumentality in painting, and he knew that he could do this only by bringing the strictest kind of order into the confused, shifting scene, by putting everything in the right place and making it stay there. In fact, he and his friends tried to reduce every aspect of painting, including color, to a series of artistic "laws." The *Grande Jatte* is surely one of the most completely "thought-through" pictures of all time, as perfectly controlled as a mural by Piero della Francesca (compare plate 36); in fact, it has a timeless dignity that is matched only by the art of ancient Egypt (plate 7). This passion for order can be seen even in the brushwork. Cézanne's brush strokes, despite their regular, pattern-like quality, still betray a strongly personal touch; with Seurat, every stroke has become a precise little dot of pure color, a tiny, impersonal "building block" in the construction of the picture (this technique is known as Pointillism).

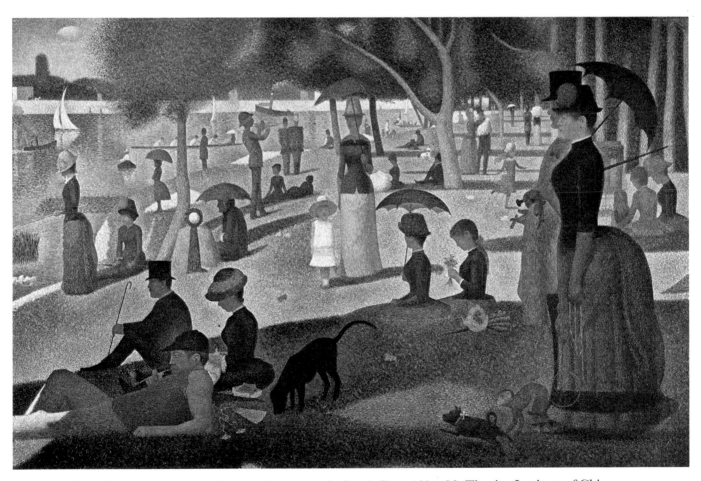

107. GEORGES SEURAT. *A Sunday Afternoon on the Grande Jatte*. 1884–86. The Art Institute of Chicago

141

VAN GOGH

While Cézanne and Seurat were making a more severe, Classical art out of the Impressionist style, Vincent van Gogh led the way in a different direction; he believed that Impressionism did not allow the artist enough freedom to express his inner feelings. Since these were his main concern, he is sometimes called an Expressionist. Van Gogh, too, wanted to "re-do the Old Masters from nature," but his heroes were Delacroix and Rembrandt rather than Ingres and Poussin. Although he was to become the first great Dutch painter since the seventeenth century, Van Gogh did not start out as an artist at all. His early interests were literature and religion; for a while he even worked as a lay preacher among the poor. Only in 1880, at the age of twenty-seven, did he turn to art, and since he died ten years later, his career was even shorter than that of Seurat. Almost all of his important works, in fact, date from the last three years of his life, which he spent mostly in the south of France. Toward the end, he began to suffer from fits of mental illness that made it more and more difficult for him to paint. Despairing of a cure, he finally decided to kill himself, for he felt very deeply that only his art made life worth living for him.

Like Cézanne and Seurat, Van Gogh reshapes nature, but for very different reasons. They stress the typical qualities of things; he picks out what is unique. With them, the artist tends to disappear behind his work; with him, every shape reveals personal feelings. Where they seek balance and stability, he creates movement. In the *Road with Cypresses* (plate 108) every stroke stands out boldly, and his passion for movement is almost overpowering. The road streams past us, the trees lick upward like flames, and the sky is filled with the whirling motion of the sun, moon, and stars. Through his personal "handwriting" Van Gogh compels us to share his own experience and what he felt about it. This magnificent vision of the unity of all forms of life expresses Van Gogh's religious feeling—a feeling as deep and strong as the faith of the Middle Ages, though it is based on his belief in the creative force within nature rather than on the Christianity of the Bible.

GAUGUIN AND SYMBOLISM

Religion also played an important part in the work (if not in the life) of Paul Gauguin, who decided to turn artist even later in his career than Van Gogh did. Until Gauguin was thirty-five, he was a prosperous businessman who painted and collected modern pictures on the side (he once owned Cézanne's *Fruit Bowl, Glass, and Apples*). By 1889, however, he had founded a new movement in art that he called Symbolism. His style, though less intensely personal than Van Gogh's, was in some ways an even bolder jump beyond the bounds of Impressionism. Gauguin felt very strongly that Western civilization was "out of joint"; that our industrial society had forced men into an incomplete kind of life devoted to making money, while their emotions lay neglected. To rediscover for himself this hidden world of feeling, Gauguin went to live among

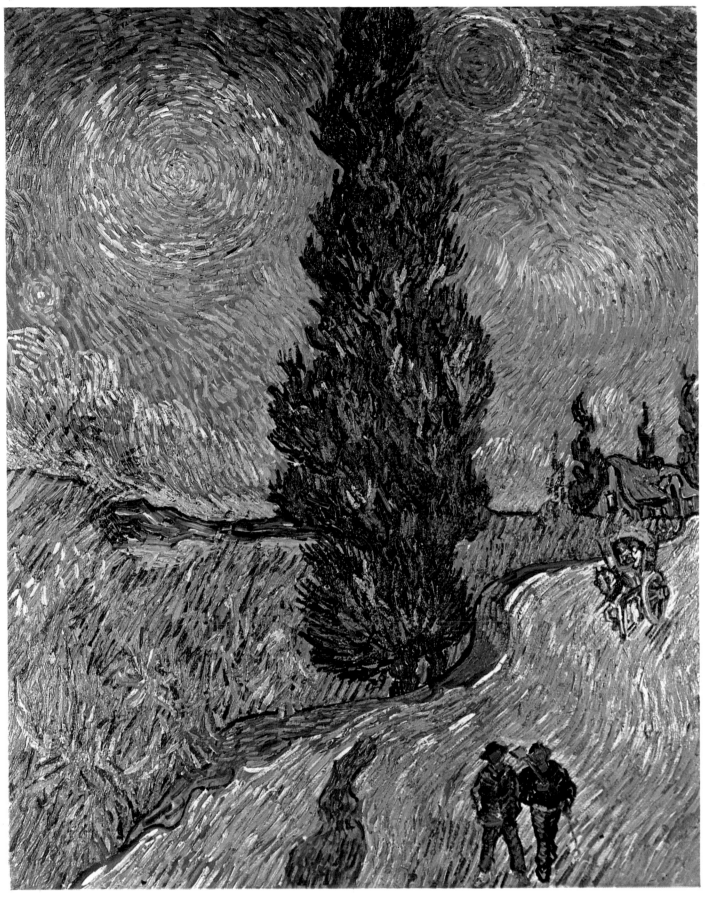

108. VINCENT VAN GOGH. *Road with Cypresses*. 1889. Kröller-Müller State Museum, Otterlo, Holland

the peasants of Brittany, in western France. He was particularly struck by the fact that religion was still part of these country people's everyday life, and in his *Yellow Christ* (plate 109) he has tried to express this simple and direct faith. The Christ, of a Late Gothic type, is on the level of folk art, since that is the way the three peasant women in the foreground think of Him. The other forms, too, have been simplified and flattened out, to stress that they are imagined, not observed from nature, and the brilliant colors are equally "un-natural." Gauguin's Symbolist style owes a good deal to medieval art (the *Yellow Christ* strongly reminds us of a piece of stained glass like the one in plate 14), yet there is one big difference: since he did not share the religious experience of the peasants, Gauguin could only paint pictures *about* faith, rather than *from* faith.

Two years later, Gauguin's search for the unspoiled life led him even farther afield. He went to the South Pacific island of Tahiti, as a sort of "missionary in reverse," who wanted to learn from the natives instead of teaching them. Gauguin spent almost ten years in this tropical setting, yet none of his pictures from this period is as

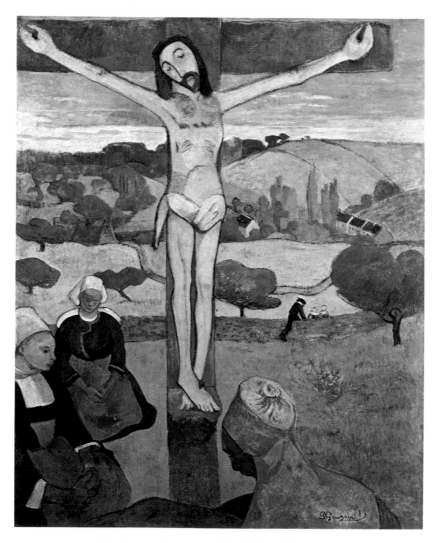

109. PAUL GAUGUIN. *The Yellow Christ*. 1889.
Albright-Knox Art Gallery, Buffalo, N. Y.

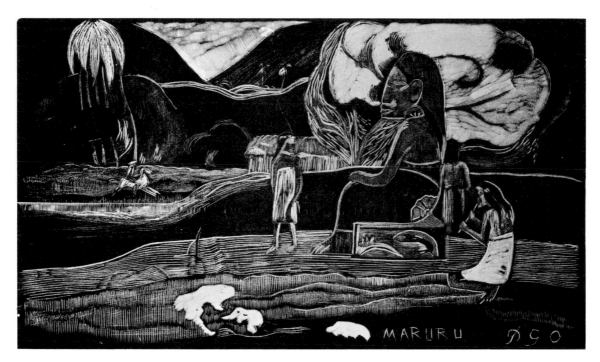

110. PAUL GAUGUIN. *Offerings of Gratitude (Maruru)*. Woodcut. About 1891–93.
Museum of Modern Art, New York

daring as the *Yellow Christ*. The most interesting works are his woodcuts; in their frankly "carved" look and their bold white-on-black patterns we can feel the influence of the native art of the South Seas. The one called *Offerings of Gratitude* (plate 110) again has religious worship for its theme, but now the image of a local god has taken the place of Christ.

PAINTING AT THE END OF THE CENTURY

The ideas Gauguin developed were taken up meanwhile by other artists of the 1890s, among them the Norwegian painter Edvard Munch. In *The Scream* (plate 111), Munch makes us "see" what it feels like to be afraid. It is a true picture of fear, the kind of terrifying fear without reason that grips us after we wake up from a nightmare. The long, wavy lines seem to carry the echo of the scream into every corner of the picture—earth and sky have become one great sounding board of fear.

There is a curiously haunted feeling in plate 112, too, even though the scene is of the inside of a well-known Paris night spot, the Moulin Rouge in Montmartre. Henri de Toulouse-Lautrec, the artist who painted this picture, was a great admirer of Degas, but he also knew Van Gogh and Gauguin. *At the Moulin Rouge* still has a good deal in common with Degas' Impressionist *Café Concert* (plate 105); there is the same sudden jump from foreground to background and contrasty lighting, the same interest in the gestures and poses of the performers. But Toulouse-Lautrec sees right

145

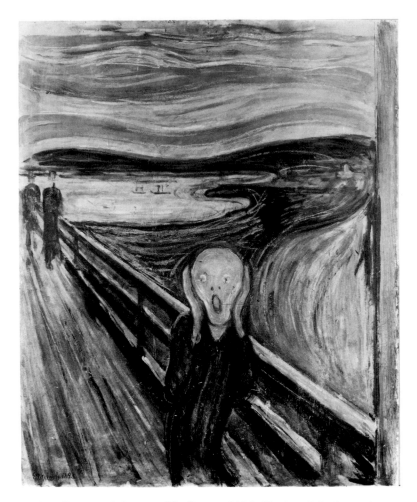

111. EDVARD MUNCH. *The Scream*. 1893. National Gallery, Oslo

through the gay surface of the scene. He views it with a cartoonist's sharp eye for character, including his own—he is the tiny, bearded man next to the very tall one in the back of the room. The large patches of flat color, on the other hand, with their dark, curving outlines, remind us of Gauguin. Toulouse-Lautrec was no Symbolist, and yet his picture means more than an Impressionist café scene. Whether he intended it or not, the artist makes us feel that this is a place of evil.

In 1886, there appeared in an exhibition of Post-Impressionist works some extraordinary pictures by a painter nobody had heard of before. His name was Henri Rousseau, and he turned out to be a retired customs official, aged forty, who had just started to paint, without training of any sort. Like all "primitive" painters of the nineteenth century, he was influenced by professional artists; *The Sleeping Gypsy* (plate 113) was inspired by a picture done by an academic artist named Jean-Léon Gérome. But Rousseau was also a genius. You will find it difficult to escape the magic spell of this dream in paint. What goes on in this calm desert landscape under the light of the full moon needs no explanation, because none is possible, but perhaps for this very reason the scene becomes unbelievably real to us. Here at last is that innocence and strength of feeling that Gauguin had thought so necessary for the Modern Age. That is why Rousseau, more than anyone else, may be called the godfather of twentieth-century painting.

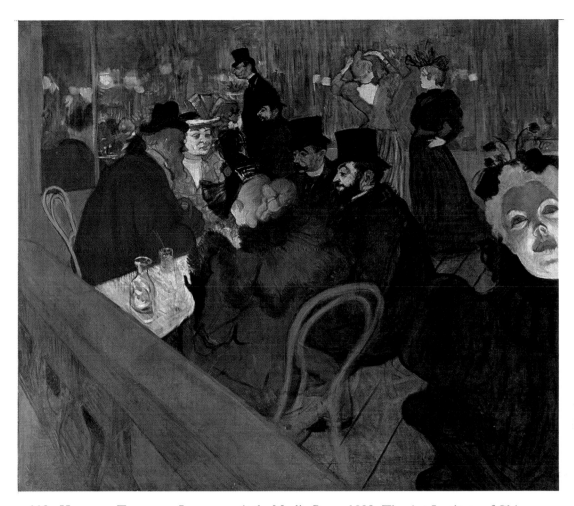

112. HENRI DE TOULOUSE-LAUTREC. *At the Moulin Rouge.* 1892. The Art Institute of Chicago

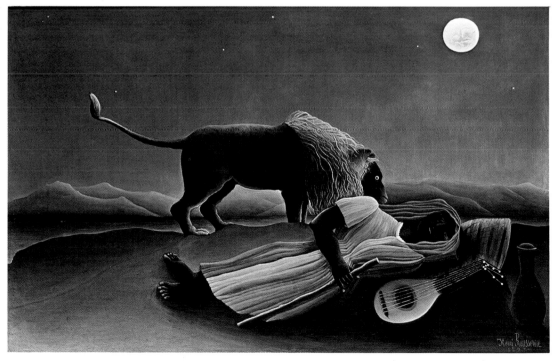

113. HENRI ROUSSEAU. *The Sleeping Gypsy.* 1897.
Museum of Modern Art, New York (Gift of Mrs. Simon Guggenheim)

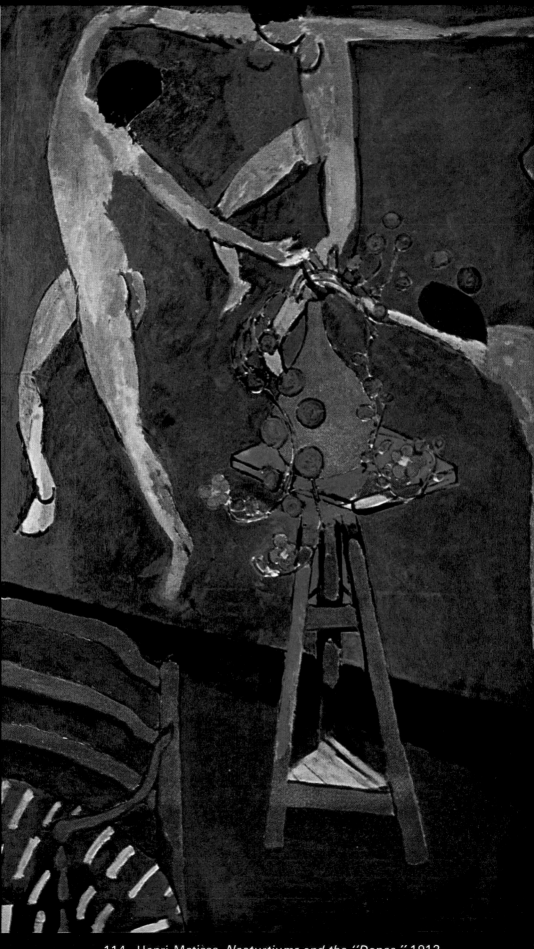

114. Henri Matisse. *Nasturtiums and the "Dance."* 1912.
Museum of Modern Western Art, Moscow (Shchukin Collection)

8

Painting
in Our
Own
Century

In our account of painting since the industrial revolution, we have mentioned quite a number of "isms": Realism, Impressionism (and Post-Impressionism), Pointillism, Expressionism, Symbolism. In the twentieth century we find even more; the past fifty years have seen so many of them come and go that nobody has yet made an exact count. Now, we are apt to find "isms" of any sort confusing, or even frightening. That is why many of us give up on modern art before we have really made a start; we don't want to cram our heads full of "isms." Actually, however, this is not necessary at all. We must always keep in mind that an "ism" is just a label to help us put things in their proper places. If it does not do that, we might as well forget about it. A good many "isms" in modern art belong to the latter kind: some of the styles or movements they are meant to label cannot be seen very clearly, while others amount to so little that only the specialist has to bother with them. After all, it is easier to think up a new label than to create something new in art that deserves a name of its own.

THE IMPORTANT "ISMS"

Still, we can't do without "isms" altogether, and for good reasons. Let us think back to the Renaissance for a moment: there we came to know many local "schools." Every country, every region, every important city had its own way of doing things, so that we often can tell at a glance where a picture of this period came from. In the Baroque era, we still found such differences, but we also saw more and more international give-and-take. Since then, this trend has grown apace. The Age of Machines has made life pretty much the same throughout the Western world; it has also forced the same problems on all of us. Today we are so involved with one another, whether we want it or not, that no man, no nation can remain an island any more. You can see why local or national "schools" are of little importance in modern art. Their place has been taken by movements, or "isms," that have a way of spreading across all boundaries. Within this bewildering variety, however, we find three main currents, and it is these that we shall keep our eye on. They all had their start among the Post-Impressionists, but in our own century they have been carried a great deal further. One of them, Expressionism, stresses the artist's feelings about himself and the world. Another, under the name of Abstraction, is concerned with the order of shapes inside the picture. And the third, which we shall call Fantastic Art, explores the realm of imagination. At this point it is well to remember that feeling, order, and imagination go into *every* work of art: without imagination, art would be deadly dull; if it had no order at all, we should find it horribly incoherent; and if there were no feeling behind it, it would leave us completely unmoved. But of course an artist may be more interested in one of these than in the others, and that is all we mean when we speak of the three currents. These currents do not correspond to specific styles,

150

but to general attitudes. They are so closely related and embrace such a wide range of approaches that the work of one artist may belong to more than one category.

MATISSE, THE FAUVES, AND EXPRESSIONISM

Twentieth-century painting actually started five years late. Deeply impressed by the work of Van Gogh, Gauguin, and Cézanne, a group of young French artists turned to Expressionism. The violent color and bold distortion in their pictures so outraged the public that they came to be known as the Fauves—that is, Wild Beasts—and they did not resent the name a bit. Their leader was Henri Matisse, who later became another of the "old masters" of modern art (he died in 1954). His *Nasturtiums and the "Dance"* (plate 114) is less violent than the first Fauve pictures, but it can still show us why their works and ideas caused such an uproar. On the wall we see Matisse's painting of a dance or Bacchanal that reminds us of Titian's (compare plate 51). Even the poses have a Classical quality. Everything in the picture is expressive, but what makes it revolutionary is its "genius of omission": whatever possibly can be, has been either left out or merely suggested. The "primitive" flavor of the forms and the flatness of design are inspired by Gauguin (see plate 109); Cézanne pioneered the integration of surface ornament into the design of the painting; but in its extreme simplicity, Matisse has certainly taken a long step beyond either of them, as if saying to himself: "Let me see what I must do to nature to change it into a decorative pattern, and yet keep it as intact as I can." Nobody has ever managed this union of opposites more gracefully than he. Unlike Van Gogh's work, the quick "handwriting" of Matisse's brush conveys no personal anguish. It tells us that he had strong feelings about one thing only—the act of painting itself. To him this experience was so profoundly joyous, like the figures themselves, that he wanted to transmit it to us in all its freshness and immediacy.

The French painter Georges Rouault, who exhibited one time with the Fauves, was the true heir of Van Gogh's deep concern with the state of the world. But Rouault found assurance in his strong Christian faith, and his pictures, such as the *Seated Clown* (plate 115), suggest sympathy and pity rather than despair. His subjects, too, are less violent and of a more familiar kind. We all know the tragic clown, outwardly gay, inwardly sad (see plate 83), but in Rouault's hands he becomes a symbol for the sufferings of all mankind. We are made to feel this from the way the picture is painted—in a style that owes much to Van Gogh and Gauguin but perhaps even more to Gothic stained-glass windows. The mood of resignation and inner suffering reminds us of Rembrandt and Daumier. Yet the expressive power of the shapes and colors belongs to Rouault alone.

The excitement stirred up by the Fauves helped to bring a lot of modern-minded foreign artists to Paris. Among them was Amedeo Modigliani, the talented Italian

115. GEORGES ROUAULT. *Seated Clown*. About 1939.
Collection The Alex Hillman Family Foundation, New York

painter who did *Girl with Braids* (plate 116). He died quite young, after an exception-
ally tragic life; perhaps that explains the wistful poetic charm of the picture. The
style, however, with its simplified, dark outlines and blocks of bright color, seems
much closer to Matisse, although Modigliani uses subtle bits of shading here and there
to lift the head away from its background.

The work of the Fauves had a particularly strong echo in Germany, where it
touched off a similar movement called Die Brücke (The Bridge). *The Dream* (plate
117) is a picture by Max Beckmann, the most powerful and original of these Ger-
man Expressionists. Beckmann came to Expressionism after his experiences in the
First World War left him with a deep feeling of despair at the state of our civilization.
Like Gauguin, he was an artist with a great deal to say. His problem was how to say
it. In order to show what he saw behind the surface of modern life, he could not sim-
ply paint the surface itself; he needed symbols, but where was he to find them? All
the old ones had long since lost their meaning—so he did what Gauguin had done:
he invented his own. But because these are *new* symbols, we must not try to "read"
them one by one, the way we do those of earlier times. Perhaps Beckmann himself

152

116. AMEDEO MODIGLIANI. *Girl with Braids*. 1917. Collection Dr. and Mrs. Ernest Kahn, Cambridge, Mass.

did not know what they stand for, any more than we can explain the things we see
in our own dreams. "These are the creatures that haunt my imagination," he seems
to say. "To me they have the power of symbols that sum up our nightmarish present-
day world. They show you the true nature of man—how weak we are, how helpless
against ourselves, in this proud era of so-called progress." His message may well
remind you of Jerome Bosch (plate 33), and there is indeed something Late Gothic
about Beckmann's tilted, zigzag world and its jerky, puppet-like figures. He has
painted a modern "ship of fools," as forceful and disquieting as the first.

The most daring and original step beyond Fauvism was taken in Germany by a
Russian painter, Wassily Kandinsky. He was the leading member of a group of

117. Max Beckmann. *The Dream*. 1921.
Collection Morton D. May, St. Louis, Mo.

118. WASSILY KANDINSKY. *Sketch I for "Composition VII."* 1913. Collection Felix Klee, Bern, Switzerland

Munich artists called Der Blaue Reiter (The Blue Horseman). After 1910 he abandoned representation altogether for a completely non-objective style, ceasing to paint any objects and using the strong rainbow colors and free brushwork of the Paris Fauves. His aim in such paintings as *Sketch I for "Composition VII"* (plate 118) was to charge the form and color with purely spiritual meaning (as he put it), by eliminating all resemblance to the physical world. The title of the picture is as abstract as the forms—but perhaps we should avoid the term "abstract" in talking about Kandinsky's work.

ABSTRACTION AND CUBISM; PICASSO AND BRAQUE

What does the word Abstraction mean? To abstract (from something) means "to draw away from, to separate." If we have ten apples and then separate the ten from the apples, we have an "abstract number," since it no longer means ten particular objects. Now let us suppose we want to make a picture of our ten apples: we will find no two of them alike. If we leave out any of these small differences, we are already "abstracting" a part of what we actually see. As a matter of fact, even the most realistic portrait of our ten apples will turn out to be an "abstraction" of sorts, because we cannot do it without leaving out *something*. Abstraction, then, goes into the making of any work of art, whether the artist knows it or not. The ancient Egyptians, for

instance, who drew the little "stick men" in plate 6, certainly did not realize they were abstracting, neither did the Greeks who made the Geometric vase in plate 9. In the Renaissance, however, artists began to abstract in a conscious and controlled way. They found that the shapes of nature were easier for the eye to grasp if you looked at them in terms of the simple and regular shapes of geometry (Piero della Francesca did this, in plate 36). Cézanne and Seurat rediscovered this method and explored it further (compare plates 106, 107); according to Cézanne, "every shape in nature is based on the sphere, the cone, and the cylinder." It was the work of these two men that really started the abstract movement in modern art.

Toward 1906, Picasso turned away from his earlier style and started painting in the manner of Cézanne. He was joined in this by his friend Georges Braque, who had been one of the Fauves until then. In the next few years, these two went a long way beyond Cézanne and created an exciting new style called Cubism. We shall understand the reason for the name if we look at Picasso's *Nude* of 1910 (plate 119), full of straight lines and right angles. But where is the nude figure? It is not easy to find at first, so we have tried to disentangle it in a sketch of our own, a sort of "skeleton key" to the picture (which you will find nearby). At this point, however, we might be even more puzzled than before. Why did the artist insist on hiding a nude among all these shapes? Would not the angles and planes have made a more beautiful design if they did not have to represent anything at all? There were some later artists who believed that, but not Picasso. To him, as to Cézanne, abstraction was "what you did to nature in order to make it fit the picture"; it had no meaning by itself. He used much tighter rules of order here than Cézanne ever did—rules that almost force him to break the human form apart entirely—but he still needed nature to challenge his creative powers. In other words, what counts is neither the nude nor the design alone, but the tension between the two.

In plate 120, Picasso has applied the same rules to a still life. Everything is broken up into angles and planes except the three letters "J O U" (whose shapes cannot be made more abstract than they are to begin with). But how can we explain the piece of imitation chair caning pasted into the picture? Why the oval shape, and the rope instead of a frame? Picasso apparently wanted to make the canvas look like a tray on which the still life is "served" to us. It is a rather witty notion of his to put the abstract "shapes of things" on top of the real things (canvas, chair caning, and rope). Picasso probably did not realize it right then and there, but he had just started to invent a new language of painting. The still life *Le Courrier* by Braque (plate 121), done a year later, shows you the next step in the growth of this new language. Here the main parts of the design are pasted together out of odd pieces of paper (this is called collage, the French word for "pasting"), with only a few drawn lines and bits of shading added to make it complete. As a result, the real and the abstract have become so thoroughly mixed up that we can no longer ask: "What is this a picture of?" Even more than before, the white paper acts as a "tray," but does the tray hold the *picture* of a still life, or the still life itself? The meaning, then, is a good deal more

120. PABLO PICASSO. *Still Life with Chair Caning*. Collage. 1911–12.
Formerly collection the artist

119. PABLO PICASSO. *Nude*. Drawing. 1910.
Metropolitan Museum of Art, New York
(Collection Alfred Stieglitz Estate)

121. GEORGES BRAQUE. *Le Courrier*. Collage. 1913.
Philadelphia Museum of Art

122. PABLO PICASSO. *Three Musicians*. 1921. Philadelphia Museum of Art
(A. E. Gallatin Collection)

complicated here than in Picasso's *Nude*, but the means have become very much simpler, since they can be found in any wastebasket.

Actually, it must have been a great strain on the artist to create balance and harmony from these chance pickings; a fine collage, such as the Braque, is a rare and beautiful thing. That is why Braque and Picasso did not continue this technique for very long. Soon they took the final step toward the new language: they began to do pictures that looked like collage but were actually painted with the brush. We can see the results in Picasso's *Three Musicians* (plate 122), one of the great masterpieces of modern times. This picture has both the size and the monumental feeling of a mural; its precisely "cut" shapes are fitted together as firmly as building blocks, yet they are not ends in themselves (if they were, the painting would look like a patchwork quilt). Every one of them has a definite meaning, and the image of the three seated, masked figures, translated into this new language, emerges more and more strongly the longer we look at it. There is space here, too, although not the kind we know from the "window-pictures" of the Renaissance: instead of looking *through* the canvas into depth, we see space in terms of the overlapping layers of shapes *in front* of the canvas. That is why Picasso could now do without shading entirely, while he had needed it in the two earlier stages of Cubism. At this point let us turn back to another musician, done some fifty years earlier: Manet's *Fife Player* (plate 92).

Painting in Our Own Century

Does he not seem the true, if youthful, grandfather of our Picasso? He ought to, for it was shadowless paintings like this one that started off the "revolution of the color patch" which had its final triumph in Collage-Cubism.

BEYOND CUBISM

For Picasso, however, there could be no standing still. Once Collage-Cubism was fully worked out, he began to show greater interest in representation, and while painting the *Three Musicians* he also painted Neo-Classic pictures such as the *Mother and Child* in plate 123. These bodies are as rounded and heavy as carved stone; it is this monumental quality, in fact, that links the two pictures together, though they are so different in other ways. Picasso's return to the warm, human world has a strength of form that he owes to his Cubist experience.

A few years later, Picasso united the experience he had gained in *Three Musicians* and *Mother and Child* to produce a new style which became the basis of all his later art. With it he achieved truly eloquent grandeur in *Guernica* (plate 124). The mural was inspired by the terror-bombing of Guernica during the Spanish Civil War. Unlike Goya's *The Third of May, 1808* (plate 93), the painting does not represent the event

123. PABLO PICASSO. *Mother and Child.* 1922.
Collection The Alex Hillman Family
Foundation, New York

124. PABLO PICASSO. *Guernica*. 1937. Museum of Modern Art, New York (Extended loan from the artist's estate)

itself, but it tells us just as movingly about the agony of war through a series of powerful images. Some of the elements are traditional. The mother and her dead child, for example, are the descendants of Mary holding Christ after He was taken down from the Cross, and the woman with the lamp may remind us of the Statue of Liberty. Others are harder to explain. Perhaps the human-headed bull represents the forces of darkness. All these figures, however, owe their terrifying quality to what they *are*, not what they *mean* in a symbolic sense. Their "distorted" appearance and violent agitation express an agonized pain and grief that is overwhelming in its intensity.

Meanwhile, the influence of Cubism had spread far and wide, not only in painting but also to sculpture, the decorative arts, and even architecture. Many painters, including a group known as the Futurists, felt that Cubism, with its abstract "system" of shapes, had a great deal in common with science and engineering, and that, for this reason, it was the only style for putting on canvas the industrial landscape of the Age of Machines. We can judge the truth of this for ourselves from our next two pictures. In *Brooklyn Bridge* (plate 125), the American painter Joseph Stella has done to a famous bridge what Picasso did to his *Nude*; but since his "model" was made by man rather than by nature (and thus was closer to abstraction from the start), he did not have to change it so much. His main task was to bring out the hidden force and impressiveness of these manufactured shapes. In his canvas the shining cables, thrusting forms, and eerie lights convey the dynamism of the bridge, which symbolized to Stella what the modern American experience is all about.

Broadway Boogie-Woogie (plate 126), done by the Dutch painter Piet Mondrian between 1941 and 1942, shortly before his death in this country, is an even more exciting picture in many ways. Mondrian was the strictest and most "architectural" of all abstract painters. He limited his palette to the primary colors, and his pictures are made up entirely of solid squares or rectangles, while all the lines have to go either straight up-and-down or across. Now, one might think that a language with such a

125. JOSEPH STELLA. *Brooklyn Bridge*. 1917. Yale University Art
Gallery, New Haven, Conn. (Collection the Société Anonyme)

126. PIET MONDRIAN. *Broadway Boogie-Woogie*. 1941–42.
Museum of Modern Art, New York

small "vocabulary" cannot possibly say a great deal, but Mondrian's painting proves that this need not be true at all; in fact, it has a spine-tingling liveliness unmatched by any other picture in this book. The entire design moves with the pulse and beat of the big city—its flashing neon signs, its stop-and-go traffic along precisely laid-out patterns. As a picture of the life that modern man has created for himself out of his mastery over the forces of nature, *Broadway Boogie-Woogie* makes Stella's *Brooklyn Bridge*, done only twenty-five years earlier, look curiously out-of-date.

PAINTERS OF FANTASY

Our third current, the one we termed "Fantasy," follows a less clear-cut course than the other two, since it depends more on a state of mind than on any particular style. The only thing all painters of fantasy have in common is the belief that "seeing with the inner eye" is more important than looking at the world outside; and since every artist has his own private inner world, his way of telling us about it is apt to be just as personal. But why should anybody *want* to tell us about his private world of daydreams and nightmares? And how could it possibly mean anything to us, since our own is bound to be different from his? It seems, though, that we are not so different from each other as all that. However good our minds may be, they are built on the same pattern. And that goes for imagination and memory, too. These belong to the unconscious part of our mind, which we cannot control at will. That is where all our experiences are stored up, whether we want to remember them or not; and at night, or when we are not thinking of anything in particular, they come back to us, and we seem to live through them again. However, the unconscious part of our mind usually does not give us back our experiences the way they actually happened. It likes to disguise them as "dream images" so that they seem less vivid and real to us and we can live with our memories more easily. This digesting of experiences is just as important for our inner well-being as the proper digesting of food.

Now, our unconscious mind digests our experiences in pretty much the same way for all of us, although it works better with some people than with others. That is why we always like to learn about imaginary things, if the person who tells us about them knows how to make them seem real. What happens in a fairy tale, for example, makes no sense at all in the matter-of-fact language of a news report but when somebody tells it "correctly" our imagination is stimulated. The same thing holds true for painting. We have already seen one very beautiful and impressive "fairy-tale picture," Rousseau's *Sleeping Gypsy* (plate 113); perhaps we shall like some of the later ones just as well.

But first we may ask, Why does private fantasy loom so large in present-day art? One reason may be the artist's greater freedom—and insecurity—in modern society. This can give him a sense of isolation and lead him to look inside himself. But the causes go further back still. The Romantic cult of emotion had prompted the artist to seek out private experiences in the first place and to accept their validity.

162

Painting in Our Own Century

The heritage of Romanticism can be seen most clearly in an astonishing picture painted in Paris just before the First World War by the Italian artist Giorgio de Chirico. *Melancholy and Mystery of a Street* (plate 127) comes closest to the imaginary reality of the *Sleeping Gypsy*. We cannot explain any of the strange things that happen in it, yet the eerie feeling of the whole is so familiar to us that we know right away we must be looking at a dream. But De Chirico was no folk artist, and his mind was much more complicated than Rousseau's. That is why his dream world seems so troubled with hidden fears, as against the wonderful calmness of the earlier picture. Marc Chagall's *I and the Village* (plate 128), in contrast, enchants us by its gaiety. In this "Cubist fairy tale," dreamlike memories of Russian folk stories and of the Russian countryside have been woven together into a glowing vision. Chagall here relives the experiences of his childhood, experiences so important to him that his

127. GIORGIO DE CHIRICO. *Mystery and Melancholy of a Street.*
1914. Private Collection

128. Marc Chagall. *I and the Village*. 1911.
Museum of Modern Art, New York (Mrs. Simon Guggenheim Fund)

imagination shaped and reshaped these memories for years without ever getting rid of them.

The "fairy tales" of the Swiss painter Paul Klee are far more purposeful and controlled than those of Chagall, even though at first they may strike us as more child-like. Klee, too, had been influenced by Cubism, but he refined and pared it down into a marvelously precise language of his own. His aim was always to create "signs," which means shapes that are images of ideas the way the *shape* "A" is an image of the *sound* "A"—except, of course, that Klee's ideas are a lot more intricate than that. One of the simpler ones is his *Twittering Machine* (plate 129), where he mocks the Age of Machines by inventing a sort of mechanical ghost that imitates bird noises. The title is of great importance, because we don't fully understand the picture unless the artist tells us what it means. The title, in turn, needs the picture. The witty idea of a twittering machine isn't very exciting until we are shown what it looks like. We know about this kind of play between words and pictures in cartoons, but Klee lifts it to the level of high art in his painting.

129. Paul Klee. *Twittering Machine*. 1922.
Museum of Modern Art, New York

DUCHAMP, DADA, AND SURREALISM

In discussing Abstraction, we saw that Cubism was used by the Futurists to glorify the machine. Because it was flexible and uniquely modern, Cubism soon entered the world of Fantasy, too, but to express exactly the opposite, a negative point of view. We find this pessimism in *The Bride* (plate 130), painted by a young Frenchman named Marcel Duchamp on the eve of the First World War. The bride hardly looks like a human being at all. What we see is a beautifully engineered machine or complicated piece of plumbing which serves no useful purpose whatever.

At the end of the war, Duchamp helped launch Dada (or Dadaism), which means hobby horse in French. The word was reportedly picked at random from a dictionary, but its childishness perfectly fitted the outlook of the new movement. The Dadaists were so revolted by the cruelty of the war that they declared Western civilization bankrupt from beginning to end. They felt they must start from scratch, respecting only one law, the law of chance, and only one reality, that of their own imaginations.

Painting in Our Own Century

Their main task, they thought, was to shock the public into the same unsettled frame of mind, and they tried to do this by exhibiting their creations, most of which were spur-of-the-moment "gestures" meant to defy all reason. The collage in plate 131 by Max Ernst, one of the leaders of the Dada movement, is more serious than that—in fact, desperately so. The picture is haunted and disturbing like the dreams of De Chirico. Ernst made it of cuttings from pictures of machinery and other technical equipment, which have been pasted together to form two nightmarish "mechanical men." These stare at us blindly through their goggles and demand to know if we recognize them as images of modern man, slave to the machine and thus little more than a machine himself.

Yet the Dada movement was not all negative. It actually helped painters to rediscover and make use of chance effects for artistic creation, as a counterweight to the purposeful discipline of Cubism. Those who believed in "taking a chance" and letting their imaginations flow unchecked founded the Surrealist movement in 1924, with Max Ernst as one of its leading spirits. It was he who introduced (or revived, rather) the technique so skillfully employed in the drawing by Salvador Dali (see

130. MARCEL DUCHAMP. *The Bride*. 1912.
The Philadelphia Museum of Art
(Louise and Walter Arensberg Collection)

131. MAX ERNST. *Two Ambiguous Figures*. 1920.
Collection Marguerite Arp-Hagenbach,
Meudon, France

166

132. MAX ERNST. *Swamp Angel*. 1940. Collection Kenneth MacPherson, Rome

133. JOAN MIRÓ. *Harlequin's Carnival*. 1924–25.
Albright-Knox Art Gallery, Buffalo, N. Y.

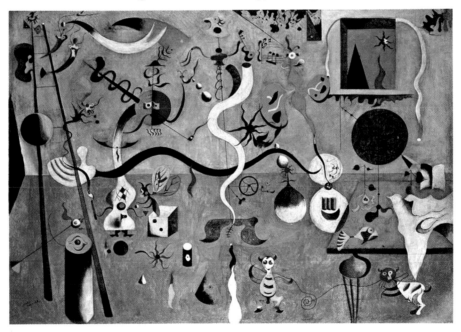

plate 3) illustrated at the beginning of this book. Using a more complicated process involving oil paints, Ernst obtained fascinating shapes and textures in *Swamp Angel* (plate 132). If his work makes us think of nightmares we have had, it is because Ernst and the Surrealists tried to transfer their dreams from the unconscious mind to canvas as directly as possible.

The Spanish artist Joan Miró had an even bolder imagination. His *Harlequin's Carnival* (plate 133) will remind you of Klee's *Twittering Machine* in some ways. It

134. Jackson Pollock. Portion of *One (#31, 1950)*. 1950. Museum of Modern Art,
New York (Gift of Sidney Janis)

looks like something one might see under a fairy-tale microscope—a lively and colorful miniature stage where everybody and everything is full of magic tricks. However, Miró had been a Cubist before he discovered his own world of fantasy, and the effortless gaiety of our picture actually comes from painstaking care in designing every detail.

ABSTRACT EXPRESSIONISM—ACTION PAINTING

Surrealism led to a new movement after the Second World War, one which has been called—misleadingly—Abstract Expressionism. One of its originators, the American painter Jackson Pollock, did the huge picture titled *One* (plate 134 shows a portion of it), mainly by pouring and spattering his colors instead of applying them with a brush. The results remind us of Ernst's *Swamp Angel* and Miró's *Harlequin's Carnival*, as well as Kandinsky's *"Composition VII."* Pollock's work, however, is so alive and rich that these earlier paintings look pale in comparison. Pollock thought of paint as a storehouse of pent-up forces, and when he released them he did not simply leave everything to chance, even though it looks as if he had "flung" pots of paint onto the canvas. He was himself the ultimate source of these forces, and he "rode" them much as a cowboy might ride a wild horse. He painted almost in a frenzy, using dancelike movements of his entire body. This points up the main difference between Pollock and his predecessors: his commitment to the *act* of painting. He was willing

168

Painting in Our Own Century

to take greater risks than any earlier artists. Now we can understand why the term Abstract Expressionism is so misleading. Pollock gave up the strict control that Abstraction requires, yet his images, unlike Expressionist paintings, do not convey his emotional attitudes. Action Painting, a term coined later, tells us much more directly what Pollock's work is all about.

Action Painting marked the coming-of-age of American art. It had great impact in Europe. The movement lost its dominant position after the late 1950s, but a number of younger artists still have a basic allegiance to it. In Paul Jenkins' *Phenomena* (plate 135) the canvas is stained—no other word will do to describe the process—by

135. PAUL JENKINS. *Phenomena Astral Signal*. 1964.
Collection Mr. and Mrs. Harry W. Anderson
(Courtesy Martha Jackson Gallery, New York)

pigments which have been made to flow in currents of different speed and density. The paint may be as thin as a veil or as thick and rich as a stained-glass window. No spattering or dribbling shows us the artist's "action." The forces that give rise to these shapes seem instead to be of the same kind as those in cloud formations in a windswept sky.

SINCE ACTION PAINTING: OP ART

Many artists have turned away from Action Painting altogether. The young American painter Frank Stella was first inspired by Mondrian but soon gave up Mondrian's vertical and horizontal format, which to him suggested windows, and made "shaped" canvases. In Stella's majestic *Empress of India* (plate 136) the shape of the canvas is a basic part of the design. To get away from the more active painting techniques of Pollock and Jenkins, the artist used a metallic spray paint that gives the surface the sheen of an automobile.

Another trend in art that began in the mid-1950s can also be traced back to Mondrian. It is called Op Art because it is concerned with optics, the physical and psychological processes that let us see. When we use our eyes in everyday life, we take it for granted that the world around us is exactly the way it looks to us. Only when our eyes "deceive" us do we begin to realize that vision is a very complicated process, that our brain has to interpret the constant stream of information transmitted from our eyes. Normally things work well, but they can go wrong by accident or intent and make us see a misleading image, one that differs from what we think is true: this is an optical illusion. Now, art has been making use of optical illusion in one way or another since the Old Stone Age; without illusion, we would not find foreshort-

136. FRANK STELLA. *Empress of India.* 1965. Collection Irving Blum, New York

137. VICTOR VASARELY. *Vega*. 1957. Collection the artist

ening so convincing, to take one example. What is new in Op Art is that it extends optical illusion to non-representational art, and makes it work in what seems every conceivable way.

The leader of Op Art is Victor Vasarely, a Hungarian who now lives in France. Much of his work is in stark black-and-white. *Vega* (plate 137), named after the brightest star in the constellation Lyra, is a huge checkerboard. Since many of the squares have been distorted, their size varies a great deal, although in a carefully calculated way. No matter where we stand we will read parts of the field as diagonals, other parts as verticals and horizontals. The picture practically forces us to move back and forth, and as we do the field itself seems to move, to expand or contract.

Op Art is still near its infancy. There are several reasons for this slow development. Op Art doesn't make the appeal to our emotions that some other movements do, so it has less popularity. Moreover, as a way of painting it requires much care and planning. And finally, since it often uses new materials and recent processes as they are developed, Op Art is in a constant state of change and its final goals are not yet in sight. However, its possibilities appear to be as unlimited as those of science and technology. Op Art will surely be with us a long time.

138. Roy Lichtenstein. *Good Morning, Darling.* 1964. Courtesy Leo Castelli Gallery, New York

POP ART; PHOTO REALISM

Pop Art, on the other hand, came of age very quickly, and within ten years had virtually run its course. It began in England in the mid-1950s and reached its fullest development in the United States in the 1960s. Pop Art is the other side of the coin from Op Art, though the two are about of an age. In reacting against Action Painting, some artists decided to return to representational art. They seized on photography, advertising, magazine illustrations, and comic books. These images are all around us and have an important, if largely unconscious, effect on our attitudes toward art. Yet they had been looked down on as "lowbrow" and "unaesthetic." Only Marcel Duchamp and a few other Dadaists, including Max Ernst (plate 131), had dared to borrow from commercial art, and they now became the patron saints of Pop Art. But Pop artists, unlike Dada, accept present-day civilization and modern art, and find in commercial culture an endless source of subjects.

The painter who best represents Pop Art may well be Roy Lichtenstein. He takes many of his subjects, such as *Good Morning, Darling* (plate 138), from traditional comic strips featuring sentimental love and violent action. It may seem a simple matter to enlarge a design from 6 to 1500 square inches, but the picture is much more than a mechanical copy of the enlargement; the thickness of the lines and the size of the dots must look "right" in comic-strip terms. What fascinates Lichtenstein about comics—

139. DON EDDY. *Silverware I*. 1976. Courtesy Nancy Hoffman Gallery, New York

and what he makes us see for the first time—is that they are so "real" to millions of people because their conventional language, as rigid and remote as in Byzantine or Egyptian art, conveys the ideals and hopes of our culture in ways that everybody knows how to "read."

Since Pop Art's chosen material, such as comic strips, and the processes it uses are in many ways abstract, it soon became increasingly occupied with formal problems of design and technique. Photo Realism, a more recent offshoot of Pop Art, sticks to the appearance of the everyday world. The movement gets its name from its fascination with camera images. Artists had begun to use photographs almost as soon as the camera was invented, early in the nineteenth century, but rarely as more than a convenient substitute for reality. The Photo Realist, however, builds his picture on the photograph itself; *it* is his reality. As with Lichtenstein's *Good Morning, Darling*, it may seem easy to enlarge a photograph and make a painting of it, but again the process is much more complicated than that. If we look carefully at *Silverware I* (plate 139) by Don Eddy, one of the best Photo Realist painters, we see that this is no simple copy of a photograph. Eddy has eliminated all the reflections we would normally see on the glass cabinet and kept only those on the silverware. Moreover, he shows everything in a uniformly sharp focus that picks up details a camera lens would lose, thereby giving greater unity to the painting. In this way he has turned a familiar scene into a rich visual experience, as dazzling as it is novel.

Index

Photographic Credits

The author and publisher wish to thank the libraries, museums, and private collectors for permitting the reproduction of works in their collections. Photographs have been supplied by the owners or custodians of the works of art except for the following, whose courtesy is gratefully acknowledged:

Alinari, Florence (16, 21, 74); Anderson, Rome (46); © A.C.L., Brussels (69); Bildarchiv Foto Marburg, Marburg/Lahn (22); Braun & Cie S. A., Mulhouse (84); Camponogara, J., Lyons (*105); Canali, Ludovico, Rome (*42, *55, *67); Chapman, William, New York (5, from the color film, "Lascaux, Cradle of Man's Art"); Clements, Geoffrey, New York (127); Devinoy, Pierre, Paris (21); Draeger Frères, Montrouge (*26); M. DuMont Schauberg, Cologne (*131); Giraudon, Paris (85); Hirmer Verlag, Munich (10); Josse, Hubert, Paris (*24, *39, *48, *50, *95); Mas, Barcelona (*51, 79, 80, *93); The Metropolitan Museum of Art, New York (7); Museum of Fine Arts, Boston (63); Pollitzer, Eric, New York (*115, *116); Pontificia Commissione per Archeologia Sacra, Rome (15); Scala, Florence (*36, *57); Service de Documentation Photographique de la Réunion des Musées Nationaux, Paris (*31, *33, *41, *44, *94); Soprintendenza alle Gallerie, Florence (34, 53); Valentin, Curt, New York (117); Vertut, Jean, Paris (*4); The Warburg Institute, London (38); Webb, John, London (*97, *98).